William Anthony  *Fine Binder*

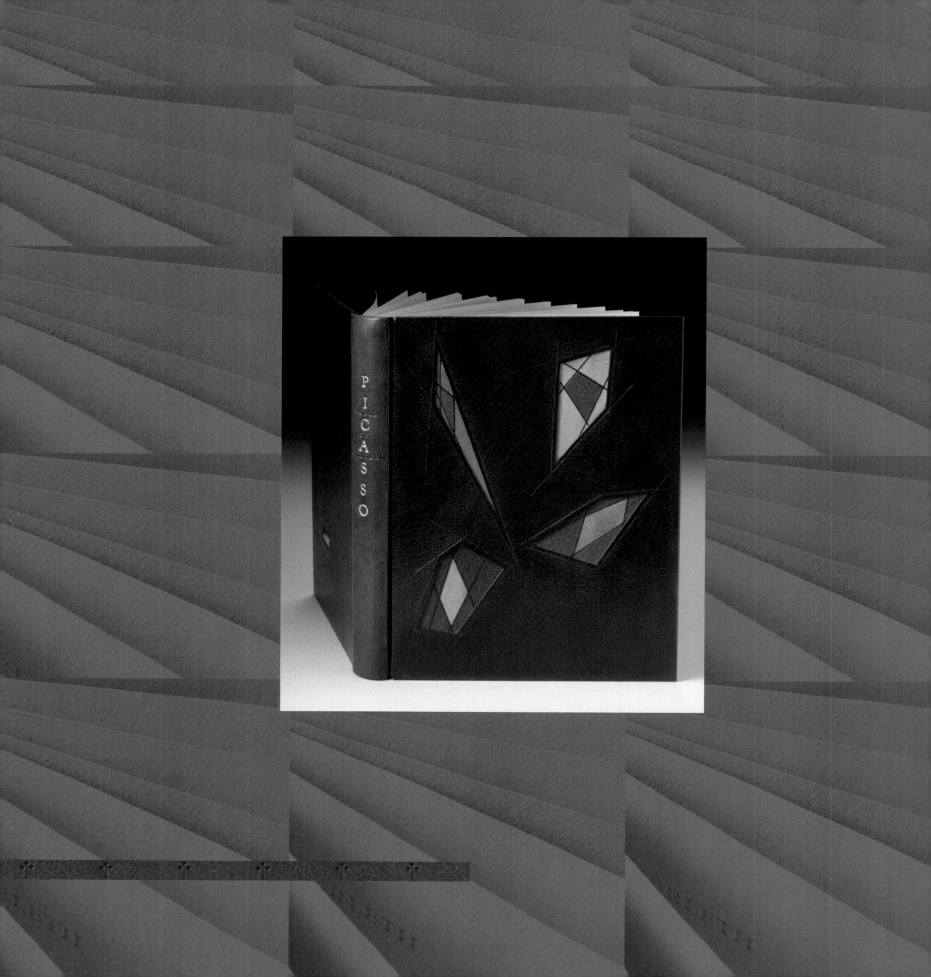

# William Anthony  Fine Binder

### edited by Lawrence Yerkes

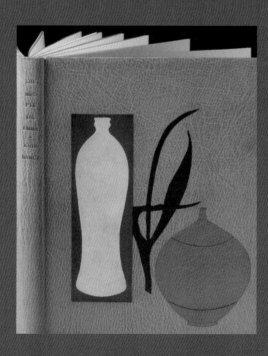

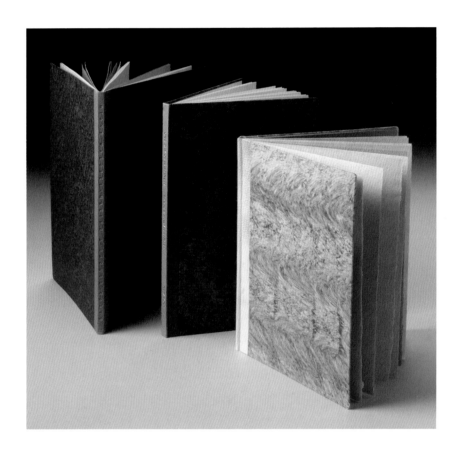

University Libraries, University of Iowa, Iowa City 52242-1420
Copyright © 2005 by the University of Iowa Libraries
All rights reserved
ISBN 0-87414-150-8

Color photographs by Jill Tobin
Black-and-white photographs from the University of Iowa Foundation
Designed by Julie Leonard and Sara T. Sauers

Published to celebrate the sesquicentennial of the University of Iowa Libraries and
commemorate the 21st anniversary of the Conservation Lab, founded by William Anthony

## Acknowledgments

AFTER BILL ANTHONY died in February 1989, his friends established a fund to support the University Libraries Conservation Lab, exhibited some of his fine bindings at Arts Iowa City, and raised money toward buying most of his fine bindings. Ultimately, his work came to the University of Iowa Libraries Special Collections Department through a partial purchase and donation by Bill's family.

Sixteen years after his death, this exhibit honors Bill in the wonderful venue of the University of Iowa Museum of Art and into the future with this catalog. In most minds, an exhibit, despite its short life, takes precedence over its catalog. However, the catalog remains long after the gallery has been emptied and another show mounted. So this catalog is our lasting memorial to Bill Anthony, for people who knew him and for all the others who did not.

In addition to fine bindings, this exhibit includes examples of Bill's edition bindings, conservation work, and historical models. While technically falling outside the definition of fine bindings, these other artifacts are as carefully planned and executed as anything Bill made.

We thank the many people who helped us assemble the bindings in this exhibit: Sidney F. Huttner and David E. Schoonover for arranging the loan of books held by the University Libraries Special Collections Department; Edwin A. Holtum for the loan of books from the John Martin Rare Book Room, Hardin Library for the Health Sciences; Dr. Ernest Mond and Annie Tremmel Wilcox for the loan of books in their possession; and the members of Bill's family who loaned books—Bernadette Anthony Dowling, Linda Jensen, Caroline Swann, John Anthony, and Lisa Dubeck. For the catalog photographs that so beautifully record these bindings, we thank Jill Tobin.

We are grateful to university staff members who generously gave their time, energy, and talent to make this exhibit possible. Barbara Yerkes spent hours transcribing, editing, and elucidating. Julie Leonard and Sara Sauers of the University of Iowa Center for the Book designed and oversaw the production of the catalog. Pamela J. Trimpe, University of Iowa Museum of Art, and Gary Frost and Kristin Alana Baum, University of Iowa Libraries Conservation Lab, coordinated the mounting of the exhibit in the museum's Hoover-Paul Gallery.

*Lawrence Yerkes*, exhibit curator

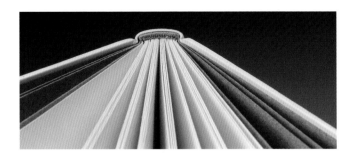

## Foreword

WHEN I BEGAN my apprenticeship with Bill Anthony in 1985, he was
chairman of the Standards Committee for the Guild of Book Workers. In
this capacity (and as organizer of the guild meeting that took place at the
University of Iowa in fall 1986 and the related exhibition of fine bindings at
the Museum of Art), Bill took many opportunities to talk to me or whoever
was in the shop about the nature of fine binding.

Bill defined a "fine binding" as a book in which all the elements are done
as well as possible. Most fine bindings are decorated, but (as I overheard
Bill explain to a binder whose undecorated book was not selected for the
guild show) if the binder chooses not to decorate the book, what is there
has to be perfect: the choice of leather, the lacing in, the size of the squares,
the evenness of the endbanding, the smoothness of the turned-in corners,
the setting of the caps. Bill considered the last two elements, caps and
corners, the most important indicators of the mastery of the binder.

I remember Bill showing me how to make a corner on a goatskin-
covered board—making the joint disappear as he worked it with his finger-
nail and smoothed it with his bone folder. Bill preferred goatskin mostly
for the beauty of its grain, but I suspect also for the possibility it offers for
making invisible corner joints.

While Bill expected something close to perfection in fine bindings, he
was not really a perfectionist. He expected his apprentices to do good work
and get better at it, but he didn't want us to labor excruciatingly over any-
thing. Once he said that mastering binding was learning how to correct
your mistakes. And we all made mistakes.

Once I made a drop-spine box, maybe my tenth or eleventh. After
putting the second tray into the nipping press, I went over to Bill's bench
and said, "I think I've finally made the perfect box." Now, Bill's method
of making boxes involved a couple of measurements at the start and then
using the piece you cut to make all the other pieces you needed. It is an
elegant system that took me a while to learn and feel comfortable using.
When you got to the last two steps, attaching the trays to the cover, you cut
scrap pieces of binder's board until they more than filled the tray. Then
you lowered the platen of the nipping press to adhere the tray to the cover,
doing the smaller tray last.

At that point you were done—unless the scraps of board above the tray
shifted and were crushing the edge of the tray. That's what happened to
my box. When I took the now less-than-perfect box out of the press, Bill
(smiling broadly) came to my rescue with his hammer and bone folder and

beat the slightly crushed side back into shape. A lesson perhaps against hubris but also that imperfections can often be fixed.

Bill apparently faced such a disaster when he executed his fine binding of *Billy Budd, Sailor*. The book was part of a traveling exhibition that wasn't over until after Bill's death. As we were looking at the returned book, admiring its beauty, we noticed that the leaves of one section had been cut out and rejoined with Japanese paper. The cut was made very close to the fold and was very neatly done. Apparently Bill was pretty far along in the binding when he discovered he had sewn one section in upside down, and he figured the only way to right the situation was to cut the leaves out and reattach them, an extremely difficult thing to do well. Bill did it well and provided two more lessons: that masters can make mistakes and can make masterly repairs.

Bill once said that Mark Esser, my predecessor as Bill's apprentice, thought that his conservation work improved after he had been working on fine binding. In Bill's case it went both ways. Conservation work and

his interest in historical models of bindings seemed to affect his choices in his last fine bindings, *Billy Budd, Sailor* in particular. And in Bill's conservation bindings (at least when a completely new binding was required for an old book), there is little that separates them from his fine bindings.

When a binder creates a new binding for a very old book, he or she has to operate within the parameters of the period the book comes from, so the binder's choices are limited (though usually not small in number). The choices the binder makes and the execution of the work can bring the work up to the level of fine binding. In fact, it was Bill's inability to do work to a low standard that kept him from executing one historically accurate aspect of tooled books from the fifteenth to the eighteenth centuries: lines that run past the designed stopping point. Bill's lines always end where they should.

Many of Bill's fine bindings don't attempt to interpret the contents of the book or express a unique artistic vision. The tooled lines and other decorations are used pretty much the way binders have used them for at least the last thousand years. Then there are the books the covers of which say something about the contents of the book. These are a subset of fine bindings that people refer to as design bindings. If you look at enough design bindings, you will see pretty much the whole range of styles that you see in other areas of art, from realism to expressionism. Bill believed that it is best not to be realistic, not to try to create the image of a boat on *Billy Budd, Sailor*, for instance, but rather to create an image which sets you in mind of the real thing.

The most interesting example of this, I think, is Bill's design for *Elegy Written in a Country Churchyard*, Bill's favorite poem. The lines on the boards look like an arbitrary if regular pattern of lines, until you realize that if you bring down one of the lines you have the outline of an old-fashioned

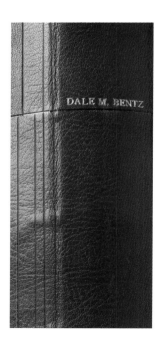

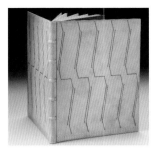

coffin. I don't know of any design he executed that pleased Bill more.

Decoration is principally an exterior aspect of the book, but sometimes the interior is decorated by the binder, especially the inside of the boards. One of the more unusual steps Bill ever took to make a book look better (if not precisely a matter of decoration) was the result of the green paper in the middle of one section of *Making a Sacher Torte*, an edition he did for the Perishable Press. The plain linen thread looked wrong against the green paper, so Bill invented a way to dye the thread green that would run the length of that one section. It was an ingenious solution that created another intersection of fine binding with one of its cousins.

Bill enjoyed working out problems, but usually he used centuries-old techniques, primarily from the English school of binding. He preferred those techniques to those of the German and French traditions, but he did not disparage the others. In fact, his favorite binders were French.

The temptation of most binders is to teach the system that they learned from their teachers. Bill was no exception, but he continued to experiment and to encourage his apprentices to try out different methods of binding—always expecting, I believe, that we would come to see his way as best.

Knowing more than one way of doing things can have benefits in special situations. Once, toward the beginning of my apprenticeship, I pared a piece of leather to reback a book, then pasted it out. When I went to put it on the book, I realized I'd made the leather too big. Bill said there was an easy solution that didn't involve waiting or paring a new piece. He said some binders actually prefer paring leather damp—and since a pasted-out bit of leather is essentially a damp bit of leather, he then pared it to the proper size. I don't know that I would ever have learned that if I hadn't made that mistake and if Bill hadn't known how other binders work.

The binders who gathered in Iowa City for the guild meeting and exhibition in 1986 had been trained in England, France, Germany, Ireland, and the United States. I didn't know a one of them. But they knew who I was, what I had done: I had gotten an apprenticeship with Bill Anthony. Throughout the three days of binding demonstrations they would come up to me, introduce themselves, and then ask me if I knew how lucky I was. I always said yes, but now I know I should have said no. At that time, I couldn't have realized how lucky I was. I hope when you look at Bill's books, you will have some idea of what I mean and will understand why we were all so lucky to have had Bill for the time that we did.

*Lawrence Yerkes*

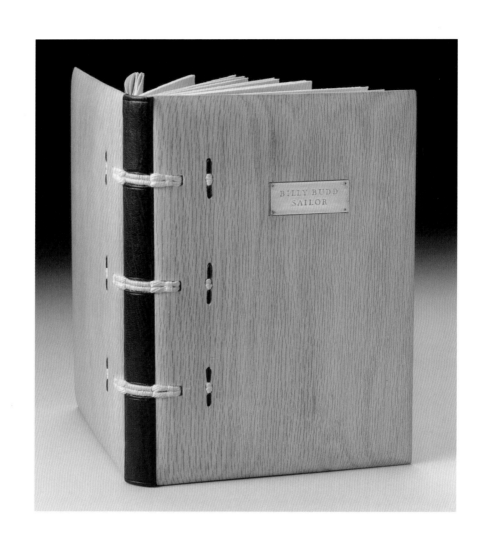

## Introduction

Bill Anthony began his bookbinding career in his native Ireland at the age of seventeen. He entered a seven-year apprenticeship program as an edition binder under the tutelage of his father, moved to another commercial bindery in Dublin, and later "grew up" as a journeyman bookbinder in London. He studied at the Camberwell College of Art and was an exhibiting member of the Guild of Contemporary Bookbinders (now known as Designer Bookbinders). Entrance to that distinguished body requires that the applicant submit "two fine bookbindings as a testament of the quality of an individual's performance in both design and execution." All this is an indication that Bill intended to be more than an edition binder early on. In 1964 he moved to the United States with his wife and family and worked for ten years in the Fine Binding Studio at the Cuneo Press, then went into partnership with Elizabeth Kner, forming Kner and Anthony, which later became Anthony and Associates upon her retirement. In the course of his later career, he worked with a number of institutions both preserving and binding various rare and valuable works in their special collections, notably the University of Iowa Libraries where he moved in 1984 to establish a conservation program.

I was the administrator of the binding and repair section at the Main Library at Iowa and was closely involved in the task of moving him from Chicago to Iowa, no small feat considering that he was attached to tons of massive bookbinding equipment. We already had the space in the Main Library and some of the equipment for him at Iowa, but artists' needs are frequently exceptional and we put considerable effort into creating a shop for Bill: we fenced in the area for security; we stocked it with a full complement of papers, leathers, and other supplies; eventually we purchased the equipment he had brought from Chicago and acquired other machines as he determined the need for them.

At Iowa, Bill was finally in a position he had aimed for all his life. He

was an artist and by necessity had been forced to be a businessman. And perhaps worse, he had been forced to use his art to make money. I have heard artists speak with disdain about their colleagues who "turn commercial" for the public. With Bill, it was not that he compromised himself—indeed, he started out his profession in a commercial venture and then became an artist doing that same work. But all

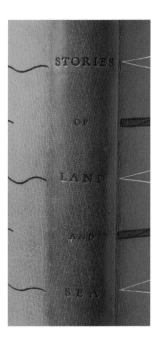

too often he could not practice his art, simply because his customers would not pay for it. His various apprentices from his commercial years speak of how he trained them to work fast and balance the degree of quality against expected remuneration. Bill spoke of the tedium of working on family Bibles. He had not rued the businessman's life: it was his profession. Iowa was certainly a change and he adapted to his new institutional freedoms early on.

For instance, Iowa has a fine collection of Dada materials which were originally built to self-destruct—the poorest-quality paper, inks, and protections were part and parcel of Dada attitudes and productions. This collection needed prompt attention, and we presented it to Bill early on. (He knew the importance of the collection, wistfully commenting once that Dada was the artistic affliction of fine minds who were living in a time and place where everyone killed everyone else.) The most important task was to stop the damage the materials were doing to themselves since the acid content of the paper was creating hundreds of highly fragile documents. Iowa has a renowned scholar of the Dada movement, Rudi Kuenzli, and he and Bill and I met to assign priorities in the treatment, very much a system of triage. A fine bookbinder from Ireland and a renowned Dada scholar from Switzerland meeting in a library in Iowa to determine what to do with the artistic productions of insane Europeans. I was merely a note taker and expediter, though I do remember assigning my own priorities when the two men were in too much of a dither to decide. Sometimes they agreed—Bill would declare something in imminent need of attention and Rudi would declare the same document of sublime importance. At other times a minor work with severe problems went to the bottom of the pile and Bill was not happy. The task took about half a day, though it would have been longer without my nagging. Experts have a hard time getting a job done: their task is to understand, not to do. The two guys couldn't stop talking about Dada and preservation, each trying hard to educate the other. Bill later referred back to that day, with bliss, as one of the most valuable of his career. It is a sure bet that he would not have spent such gainless hours were he still back in Chicago trying to feed his wife and babies.

This exhibition features one part of his career. Here is Bill Anthony creating beautiful works of art. I think it correct to say that he did not consider fine binding to be the most important aspect of his vocation. He was fervently devoted to conserving valuable works in need of attention and he avidly believed that training others to do the same was a requirement of his profession. He introduced an apprenticeship program in Chicago, even though training novices was an expensive undertaking. Of course the institutional setting in which he finally ended allowed and encouraged his enthusiasm, and Iowa now proudly supports a vigorous program in the preservation and conservation of library materials, a program largely brought about by his efforts.

In the words of one of his students, presenting and showing fine bindings is like the musician who must give recitals: it is a requirement of the profession. Bill was a somewhat reluctant artist. Not reluctant to do

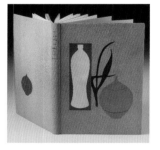

the work, but reluctant to show and claim it. He had the disturbing habit of signing his bindings only when he remembered to, a bad quirk few artists practice. And he did not seek out praise. In discussing one of his failures (a binding which he did not complete), he says: "Sometimes the whole thing works. All the parts come together, the paper, the typography, the forwarding, covering, and the image on the cover to form a beautiful book. I would be expecting too much for this to happen all the time. It's expecting a lot for it to happen even once."[1] Even once? What to make of that when we look at all these beautiful bindings? I can find only one mention by him that he was happy with his work, that being his creation of *Billy Budd, Sailor* (page 42). He discusses his choice of materials and ends by stating, "I am satisfied that the book is harmonious in all of its parts."[2] And what would be his critique of the other bindings here? I notice a couple of mistakes. One of the bindings doesn't open well, perhaps one of the worst iniquities in Bill's notion of good binding. In this case it was the fault of the material (vellum) drying over time, though I feel certain that Bill would argue that a good binder must know his materials. In another case he misspelled the name Rackham, omitting the letter "h" (page 8). (I suspect that he would have felt that not too great a sin: binders are largely illiterate

when handling books. Upside down, backward, Aramaic, they don't care. Or perhaps he might comment, as he did on a botched job from one of his students, "A man galloping by on a horse wouldn't notice it.") But these books are a delight. A librarian colleague, one suspicious of any notions that a book might be a work of art, once complained that beautiful bindings distract from content. Indeed this can be the case when the binding is inappropriate. But Bill's bindings are appropriate: they arrest the senses and drop the reader into an ambience with the book before it is even opened.

Many of the works in this exhibition are design bindings, a term used for bindings which reflect the content of the book. Design binding began in the twentieth century and largely signaled the progress of the profession from one of craft to one of art. Bill's harmonious *Billy Budd, Sailor* was part of an exhibition of a number of bindings of the same book, reflecting the various binders' artistic creations. The results are an engaging display of how these artists think.[3]

This exhibition is a fine history of the progress of his art over the years. *The Christmas Book* (page 44) and *The Holy Bible* (page 35) are early bindings and both are lovely and simple with a holly leaf and cross respectively; later bindings such as *The Mud-Pie Dilemma* (page 10) and *Chicago Sculpture* (page 40) along with *Billy Budd, Sailor* are sophisticated designs requiring considerable expertise.

It is certainly not necessary to understand the nature of a book in order to bind it, and many fine binders do produce bindings which in no way reflect the books' contents. Not all of the books in this exhibition are design

bindings. Note particularly *Photographs of Handtooled Bindings Executed in the Studio of the Cuneo Press, Inc.* (page 22). Bill bound this book while employed at Cuneo; indeed, the attribution stamped onto the inside front cover states *Made by Cuneo*, with no indication that Bill was the binder. It is serviceable and handsome enough, but the binding adds nothing to the experience of looking at the book—except insofar as all the photographs of the fine bindings from Cuneo on these pages look very much the same as the binding Bill chose: typically leather with a common geometric or heraldic design in gold or blind tooling. Rather like the wrapper for a gift which gives no hint of what's inside.

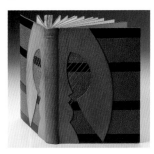

Bill was first and foremost a teacher and preservationist, but he found great joy in his art. In his words: "All that I do with the binding and the cover relates to the contents in some way that satisfies me. I want it to be harmonious and tasteful and beautifully executed." At times his bindings are self-evident: Reidy's *Chicago Sculpture* has a Chicago sculpture on the cover (page 40); Koch's *Tales for Bibliophiles* has a shelf with books (page 31); Austin's *Birds of the World* is a graceful design of intersecting straight and curved lines representing longitude, latitude, and flying birds (page 45); the Arthur Rackham book of fairy tales has mushrooms (page 8). But sometimes the content is cerebral rather than material, and what does the artist do then to satisfy himself? One of the least flashy and loveliest books in the exhibit is *The Charm* by Robert Creeley (page 30). It is a quiet little binding on a quiet little book. Creeley's poetry is sparse, with few characterizations or incidents. He is a clean writer, each word carrying its full weight, as in "Return":

> Quiet as is proper for such places;
> The street, subdued, half-snow, half-rain
> Endless, but ending in the darkened doors.

And the binding doesn't jump out at you either—too many other colorful things on either side. It is sparse also: black with gray-feathered overlays, suggesting a faint layer of clouds, and then a sharp, clean zigzag in gold.

There is one curious book in the exhibition, *Poetry in Crystal* (page 11) by Steuben Glass, which imposes one more hurdle on the design binder. It is a book of poetry written by contemporary poets at the invitation of Steuben Glass. The company's artists created glass works based on the various poems. The design binder must somehow balance the work of the poet, the glass designer, and the glass engraver and produce a harmonious whole. (The original cloth binding from the publisher was merely red cloth with gold stamping.) Bill created a felicitous binding of tan calf, a brown circular onlay with a graceful gold-tooled design, and at its center a green faceted piece of glass. He smiled as he laid on that piece of glass.

He knew what was in the books. Perhaps he did not read all of every one

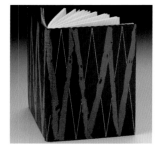

of them—surely not the two volume *Judas der Ertz-Schelm* (page 48), a lumbering Germanic treatise on Judas Iscariot, but he thought about what he was binding, for these volumes are appropriately ominous. On the other hand, I know he read Creeley's poems because that binding so appropriately illustrates the poetry. Here is how he does it: "I rarely have the discipline or the inclination to design both the binding and the cover decoration at the outset. I am more comfortable concentrating on the binding; designing the structure, the forwarding, and the cover, enjoying the pleasure of executing the work while noting and sketching ideas that come to mind for the cover image."[4]

Bill's students and friends frequently describe him as humble, and I cannot agree with them, though I understand the error. He had all the trappings of humility: he was quiet, polite, politic, thoughtful, careful, in no way brash. All that, but he wasn't humble. Never would he have tugged at his forelock. The opposite of humility is arrogance, and he was not arrogant. But he was an egoist—an egoist in the finest sense. He firmly knew what was right and what was wrong; he knew what was beautiful and what was ugly and he acted and created from this sensibility. These books are right and beautiful. Or to use his words, the books are in harmony, as was he himself.

*Helen B. Ryan*

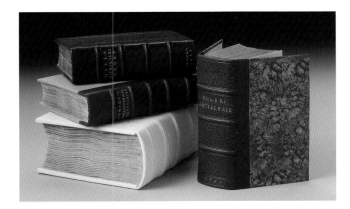

1. Bill Anthony, "Harmony of Parts in Fine Binding," *Guild of Contemporary Book Binders, 80 Years Later*, Guild of Book Workers, New York, 1986, page 23.

2. *Bound to Vary*, Guild of Book Workers, New York, 1988, page 30.

3. That exhibition is collected in *Bound to Vary*, Guild of Book Workers, New York, 1988.

4. Anthony, "Harmony of Parts in Fine Binding," page 23.

# Fine & Edition Bindings

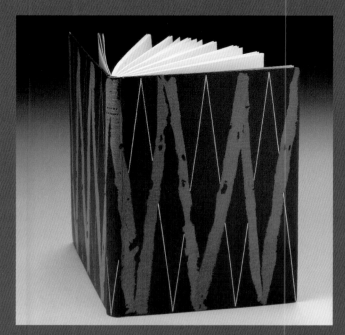

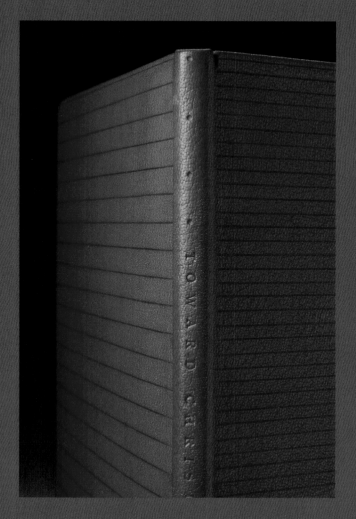

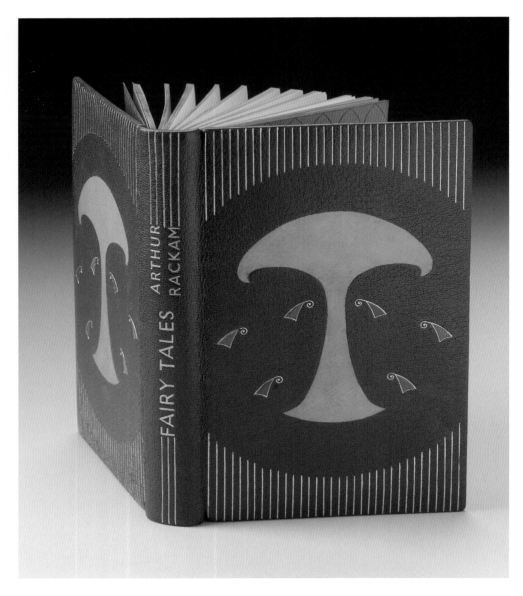

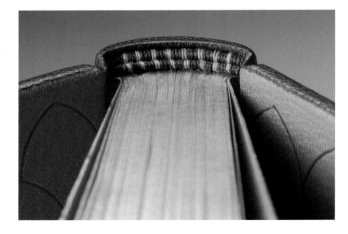

An edge-to-edge leather doublure tooled in a diaper pattern. Double-core endbands.

*The Arthur Rackham Fairy Book* by Arthur Rackham
London: George G. Harrap Company, 1948
Date of binding 1956

Full brown goatskin with tan goatskin onlays in form of mushroom and varied color onlays with gold tooling. Handsewn double endbands. Edges gilt. Orange oasis doublures and endpapers, blind-stamped.
8 5/8 x 5 1/2 inches.

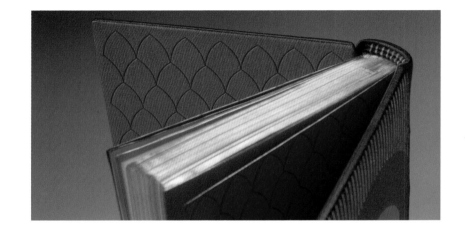

*A Harvest of Reeds* by Charles G. Blander
Chicago: Blue Sky Press, 1902
Date of binding 1983

Full tan oasis with orange and green onlays in form of sun and reeds. Handsewn silk
endbands. Original front printed wrapper bound in at rear. 6 1/8 x 4 1/2 inches.
Loaned by Linda Jensen.

*The Mud-Pie Dilemma* by John Nance
Forest Grove, Oregon: Timber Press, 1978
Date of binding  1979

Full light brown oasis with leather and vellum onlays in forms of two vessels and a plant;
blind-tooled. Gray paper pastedowns and flyleaves. Handsewn silk endbands. 11 x 8 inches.

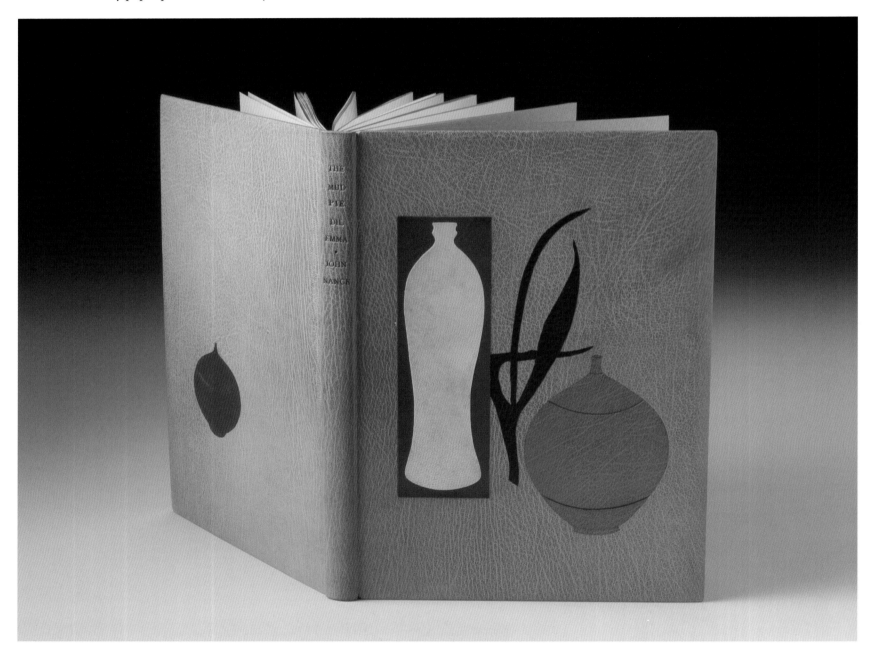

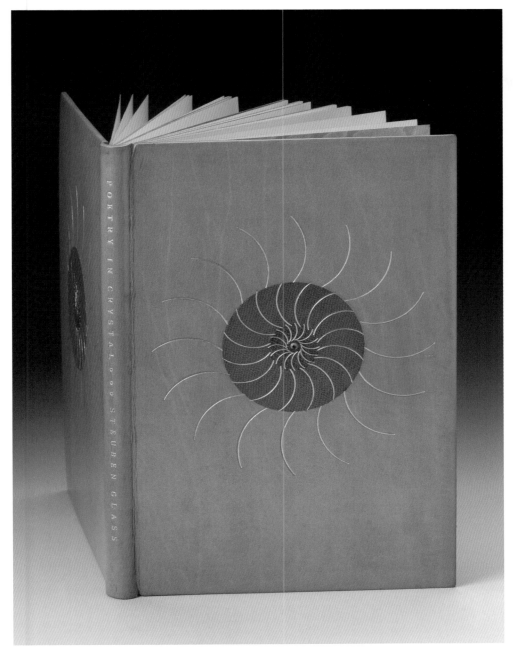

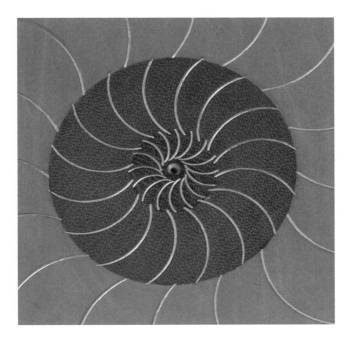

This is the only instance of Bill's mounting a "jewel" on the board of a book. The overall design of radiating curved gold lines is reminiscent of designs by one of Bill's favorite binders, the Frenchman Paul Bonet. A poster of a similar, if more elaborate, binding by Bonet hung on the wall above Bill's desk in the Conservation Lab.

*Poetry in Crystal* by Steuben Glass
New York: Spiral Press, 1963
Date of binding 1963

Full golden brown calf with onlay of brown leather in circular form with green stone in center. Handsewn endbands. Edges gilt. Calf turn-ins with pastedowns and flyleaves of green oriental paper. 10 5/8 x 7 1/4 inches.

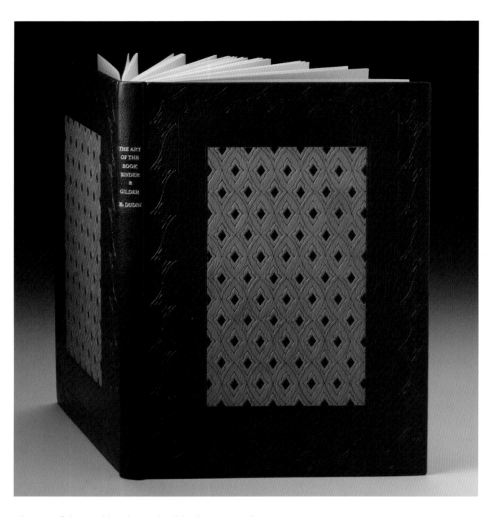

*The Art of the Bookbinder and Gilder* by M. Dudin
Leeds: Elmete Press, 1977
Date of binding 1978

Full dark brown goatskin with onlays of light brown and brown goatskin in repeated diamond pattern, blind-tooled. Title and author gold-tooled on spine. 14 x 10 inches.

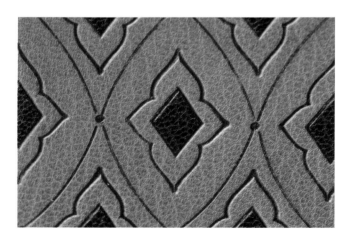

Bill interpreted many traditional designs. Here the board decoration is an elaborate diaper pattern— an organization of lines or elements (here, diamonds, dots, and wavy lines) diagonally across a panel on the boards.

Binders have always been challenged to fit a long title across a narrow spine. This is an example of Bill's elegant use of handle letters.

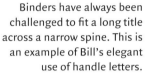

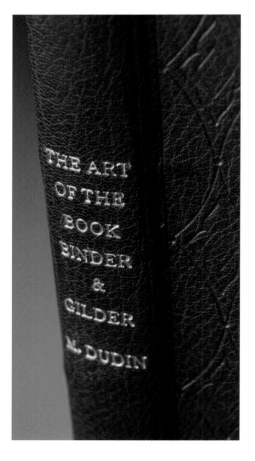

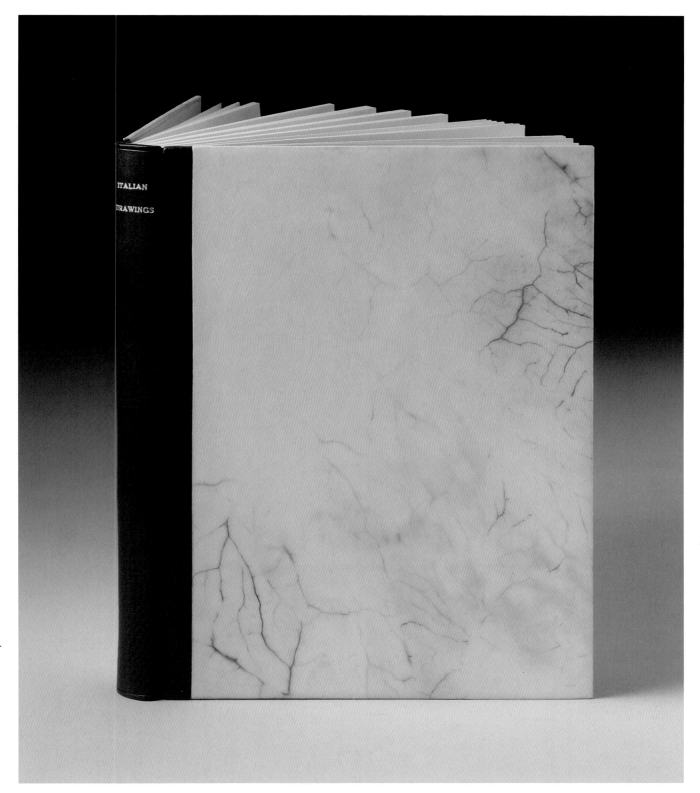

*Italian Drawings in the Art Institute of Chicago* by Harold Joachim and Suzanne Folds McCullagh
Chicago: University of Chicago Press, 1979
Date of binding 1979

Veined vellum over boards, dark green oasis spine with blind and gold tooling. Handsewn silk endbands.
11 x 8 1/4 inches.

*A Collection of Stories of Land and Sea from the Late 19th Century*
Chicago: Cuneo Press, 1956
Date of binding circa 1966–1973

Full tan oasis with red and green goatskin onlays, blind and gold tooling on front cover, blind tooling on back cover. Onlays and tooling in straight and wave forms representing land and sea. Oasis turn-ins with blue-green marbled paper pastedowns and flyleaves. 9 1/4 x 6 1/2 inches.

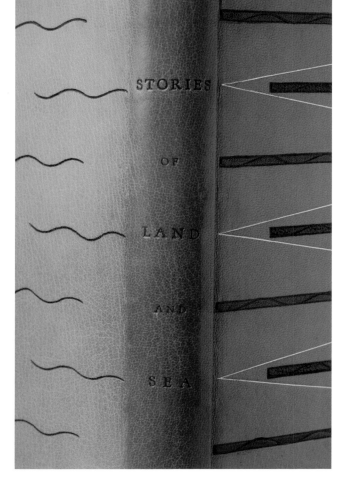

The abstract representations of sea and land are different on each board and yet flow from board to board and across the spine titling.

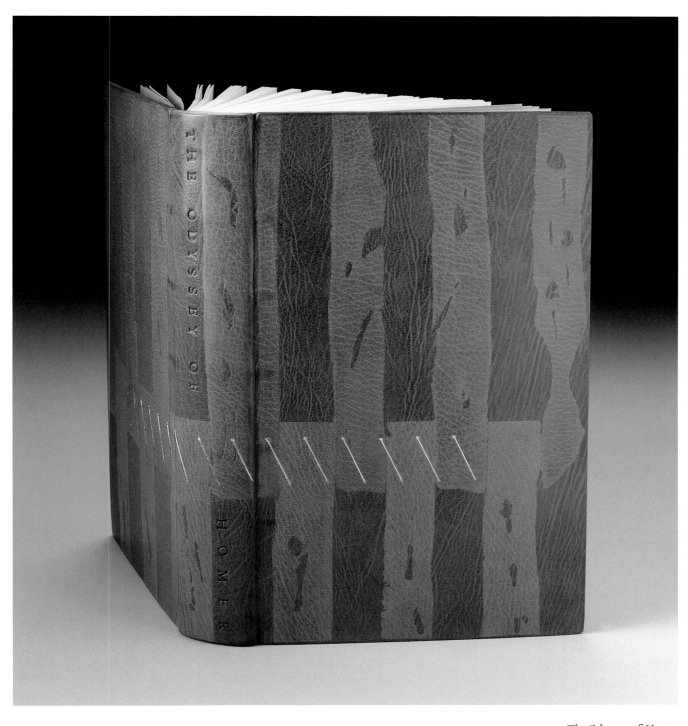

*The Odyssey of Homer*
New York: Limited Editions Club, 1981
Date of binding 1984

Full gray goatskin with leather onlays.
Blind- and gold-tooled. Handsewn silk endbands.
11 x 7 inches. Loaned by Dr. Ernest Mond.

*Dale M. Bentz*
Letters presented to Dale M. Bentz on the occasion of his retirement in 1986
Date of binding  1986

Full maroon goatskin with leather onlays. Blind- and gold-tooled. Handsewn
silk endbands. Marbled paper doublures and endpapers. 12 15/16 x 10 inches.

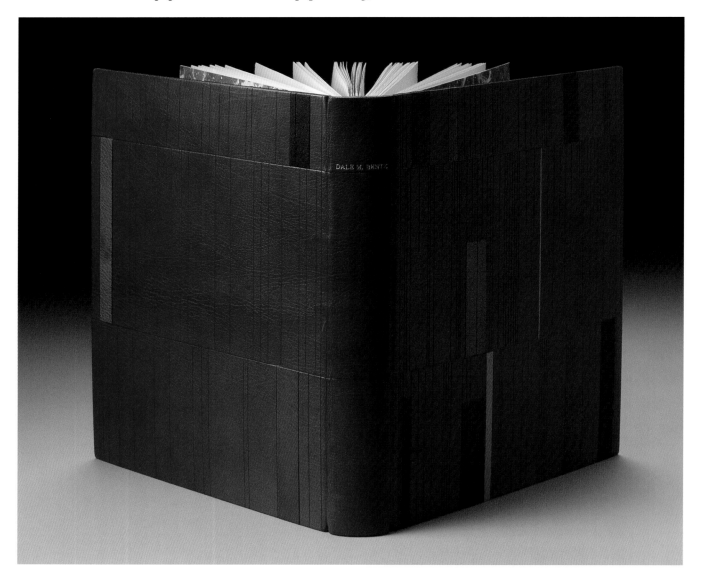

Note how the cords are evident under the leather, where they are laced into the boards. Cords are sometimes thinned to make them invisible. Bill preferred to leave them thick so that the textblock would be more strongly attached to the boards.

*Sonnets from the Portuguese* by Elizabeth Barrett Browning
New York: Limited Editions Club, 1948
Date of binding 1988

Full blue goatskin with leather onlays and raised areas.
Blind- and gold-tooled. Handsewn silk endbands.
Marbled paper doublures and endpapers.
15 x 10 11/16 inches. Loaned by Dr. Ernest Mond.

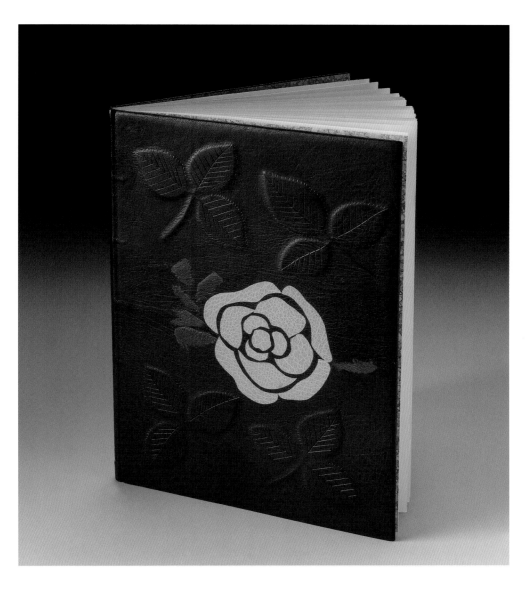

Bill occasionally used marbled paper for endpapers, though more commonly he used plain colored paper or the same paper as the text.

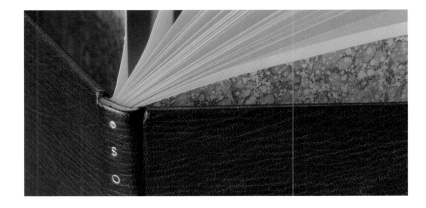

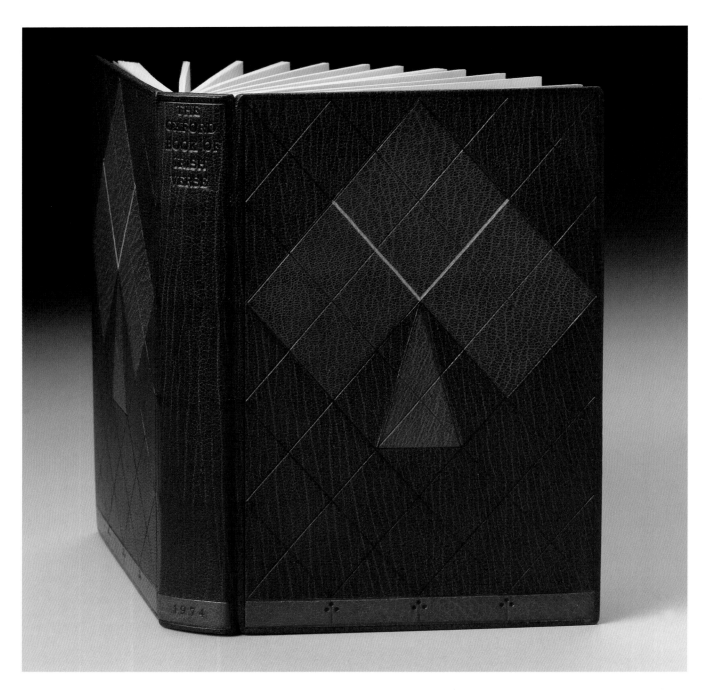

*The Oxford Book of Irish Verse*
Oxford: Clarendon Press, 1974
Date of binding 1975

Full green cloth oasis with lighter green oasis inlay in shamrock form with red oasis onlay border across lower edge of front and rear covers. Blind- and gold-tooled. Tan paper pastedowns and flyleaves. Handsewn silk endbands. 7 1/4 x 5 inches.

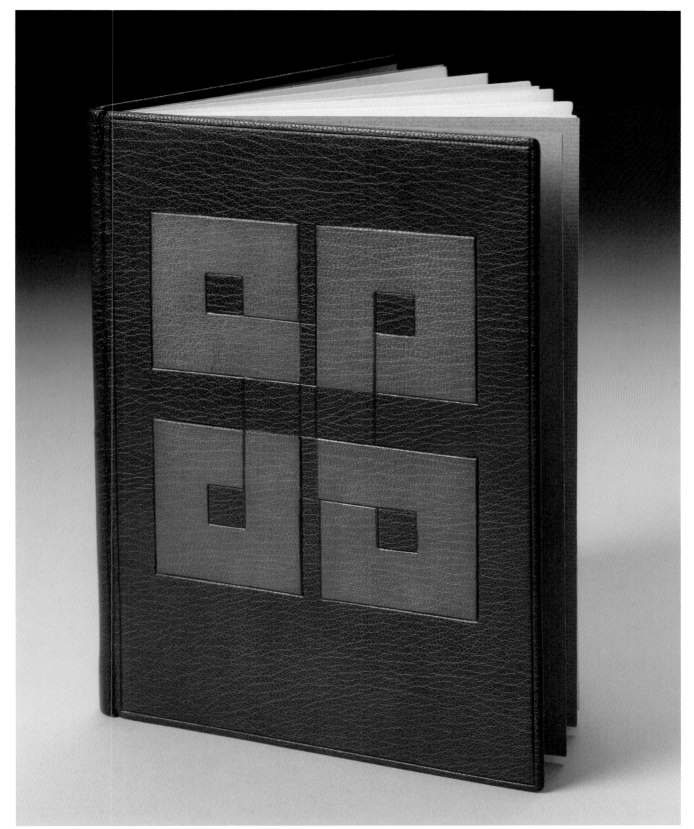

*A Vision and the
Dream of Petrarca*
by Walter Savage Lander
Chicago:
Will H. Ransom, 1903
Date of binding  1979

Full green oasis with red
oasis onlay in form of four
squares linked with blind-
tooled lines. Handsewn
silk endbands.
6 7/8 x 5 inches.

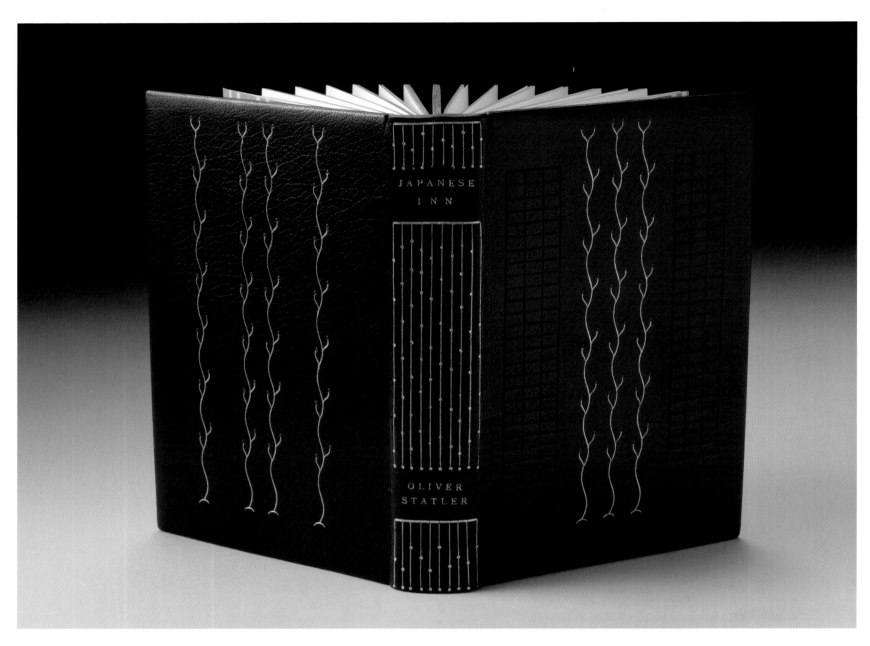

*Japanese Inn* by Oliver Statler
New York: Random House, 1961
Date of binding 1963

Full black goatskin with red leather onlay and blind and gold tooling simulating
forms of plants and Japanese screens. Edges gilt. 9 3/8 x 6 1/4 inches.

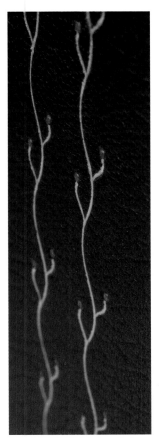

Bill made the design with several small tools impressed singly many times to create the curved lines and branches.

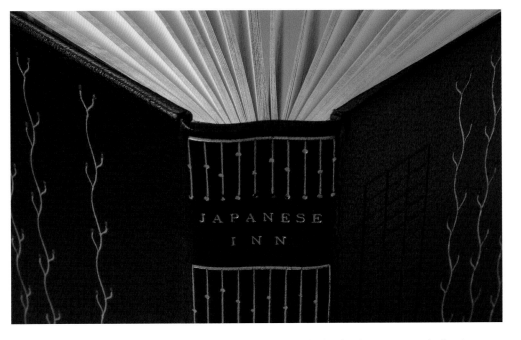

Note how the tight-back spine moves as the book opens.

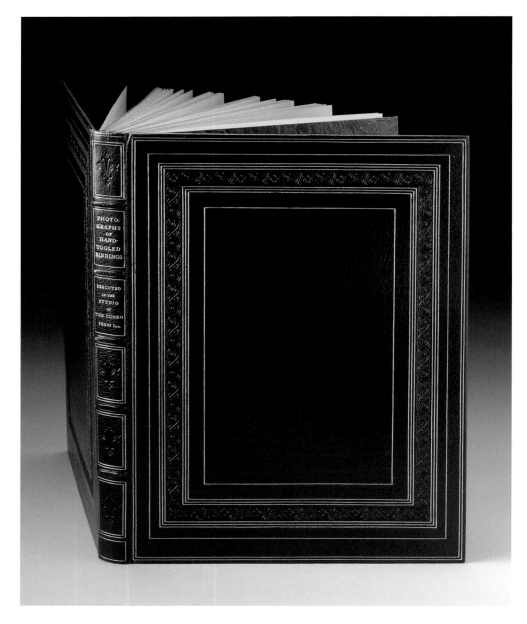

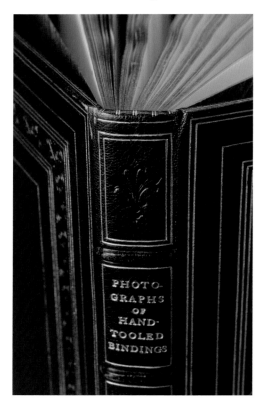

This detail reveals Bill's mastery of extra binding at the Cuneo Press.

*Photographs of Handtooled Bindings Executed in the Studio of the Cuneo Press, Inc.*
Chicago, no date
Album with hand-lettered title leaf, containing approximately fifty-eight black-and-white original photographs with hand-lettered captions.
Date of binding  circa 1966–1973

Full brown goatskin with blind- and gold-tooled border on front and back covers. Handsewn silk endbands. Goatskin doublure border with marbled paper pastedowns and flyleaves. 14 x 11 inches.

The calligraphy on the spine is typical of early vellum bindings, on which the book owner sometimes wrote the title. This binding is also reminiscent of vellum bindings of the Arts and Crafts movement of the late nineteenth century.

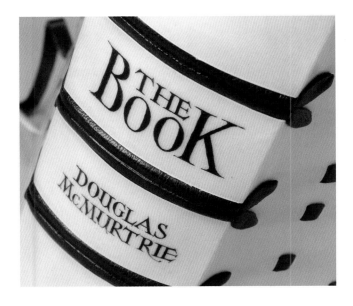

*The Book* by Douglas McMurtrie
London & New York: Oxford University Press, 1976
Date of binding 1980

Full limp vellum, sewn on four double-raised thongs of brown oasis laced across covers with oasis thongs and bone clasps. Spine hand-lettered by Gertrude Carrier. 9 7/8 x 7 1/2 inches.

*The Nature and Making of Parchment* by Ronald Reed
Leeds: Elmete Press, 1975
Date of binding 1976

Full brown goatskin with blind-stamped decoration.
Sewn on four frayed-out cords. Handsewn silk endbands.
11 x 8 inches.

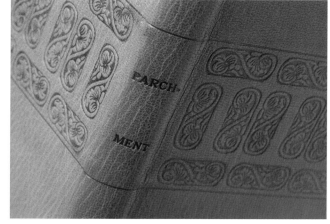

Blind tooling may stand alone,
or it may be the preliminary
step to gold tooling. It is very
difficult to do blind tooling with
consistent color and depth.

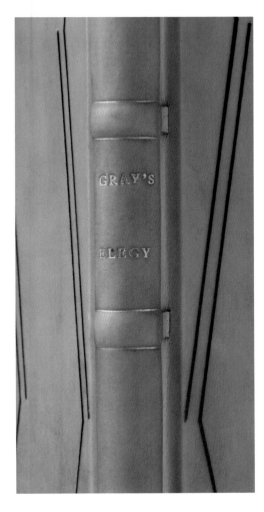

Unlike leather, vellum does not darken when pressed with a hot tool. Bill had to color the lines in with ink.

*Elegy Written in a Country Church Yard* by Thomas Gray
Calligraphy by Colin Pointer
Date of binding 1964

Full vellum with linear design applied in black ink with gold tooling, title gold-tooled. Sewn on five alum-tawed pigskin thongs. Brown oriental paper pastedowns and fly-leaves. 12 x 9 1/4 inches. Loaned by Caroline Swann.

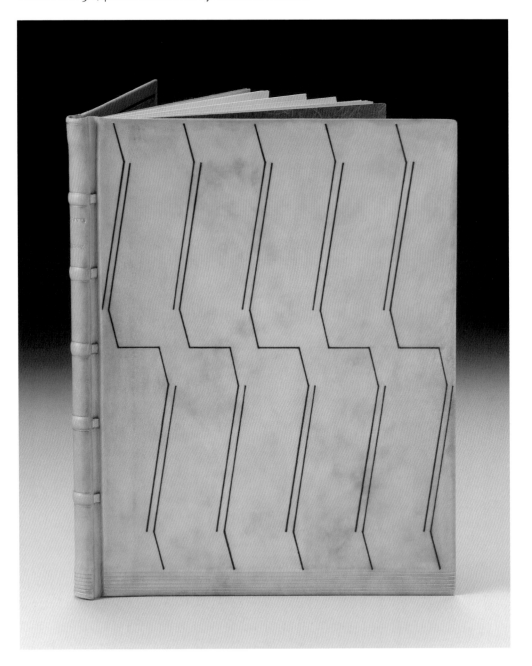

Like vellum, alum-tawed skins do not darken much when tooled but can be tooled in gold. Note that the classic diaper pattern on the boards is outside the central panel, where one might have expected to find it.

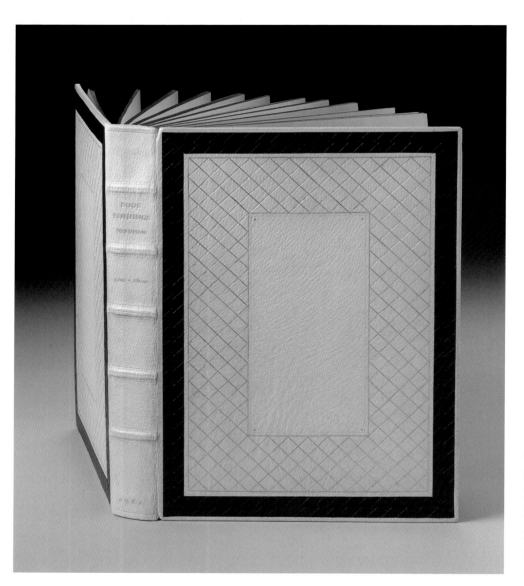

*Twelve Centuries of Bookbindings, 400–1600* by Paul Needham
New York & London:
Pierpont Morgan Library/Oxford University Press, 1979
Date of binding 1981

Full alum-tawed pigskin with black goatskin onlay border and gold-tooled diaper pattern. Sewn on five double-raised cords. 12 1/4 x 9 1/4 inches.

*Love Letters of Henry VIII
to Anne Boleyn*
Herrin, Illinois:
Violet & Hal W. Trovillion,
1945
Date of binding  1985

Dark navy oasis with
gold-tooled roses. Title
gold-tooled on spine with
onlay dots of red oasis.
Handsewn silk endbands.
7 5/8 x 3 3/4 inches.
Loaned by Lisa Dubeck.

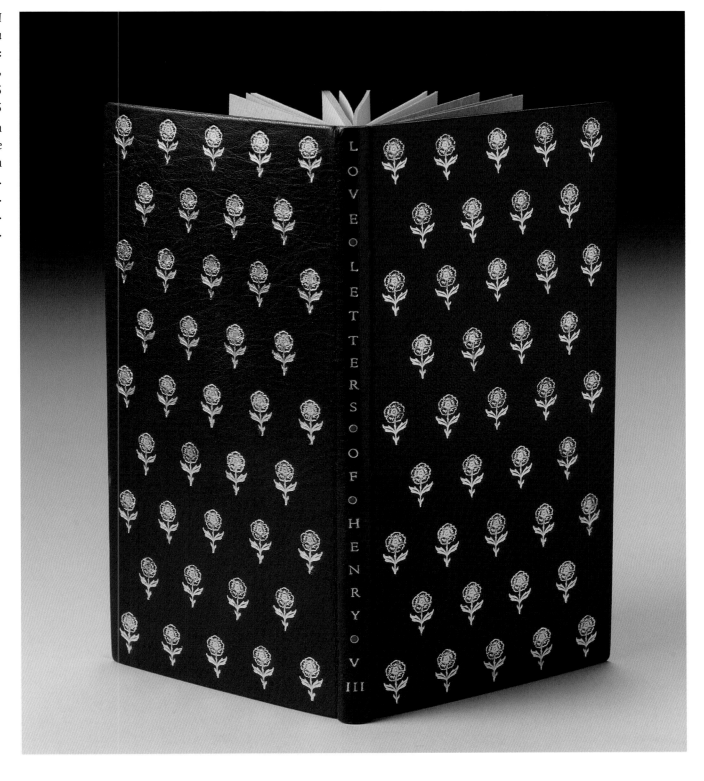

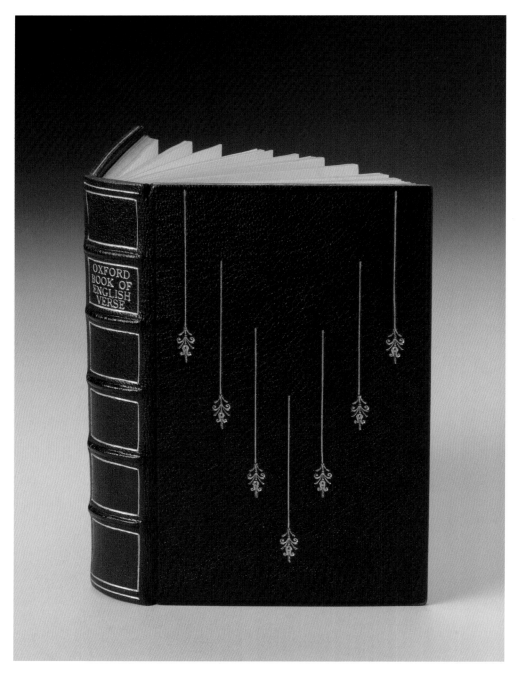

Bill made the decorations on the boards with a brass roll for the lines and a floral figure to end each line.

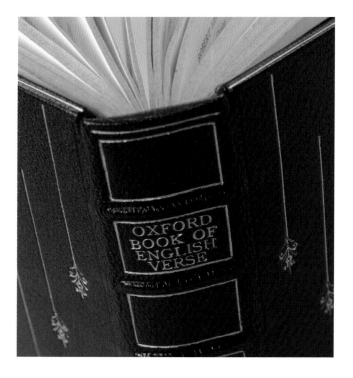

*The Oxford Book of English Verse: 1250–1918*
Oxford: Clarendon Press, 1955
Date of binding  1978

Full black oasis, blind- and gold-tooled. Handsewn silk endbands. Royal purple oasis doublures and endpapers. 6 1/2 x 4 1/2 inches.

*44 Wilde 1944: Being a Selection of 44 Images from a Sketchbook Kept by John Wilde Mostly in 1944*
by John Wilde
Mt. Horeb, Wisconsin: Perishable Press Limited, 1984
Date of binding 1984

Full alum-tawed goatskin with black oasis onlays. Gray paper pastedowns and flyleaves.
10 x 7 1/4 inches.

Elegant, small squares and perfectly formed caps were a point of pride with Bill.

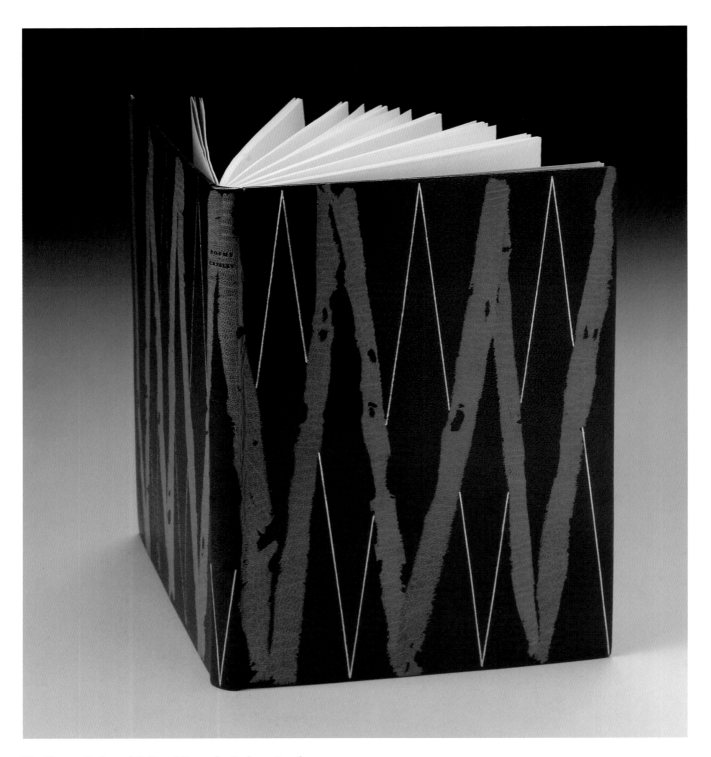

*The Charm: Early and Collected Poems* by Robert Creeley
Mt. Horeb, Wisconsin: Perishable Press Limited, 1967
Date of binding 1973

Full black oasis with gray oasis onlays and gold tooling. Handsewn silk
endbands. Gray paper pastedowns and flyleaves. 8 1/4 x 5 3/4 inches.

*Tales for Bibliophiles* by Theodore W. Koch
Chicago: Caxton Club, 1929
Date of binding 1982

Full red goatskin with tan leather onlays and blind and gold tooling simulating the appearance
of books on shelves. Handsewn silk endbands. Red goatskin turn-ins with gold and blind tooling.
Green paper pastedowns and flyleaves. 8 1/4 x 5 5/8 inches.

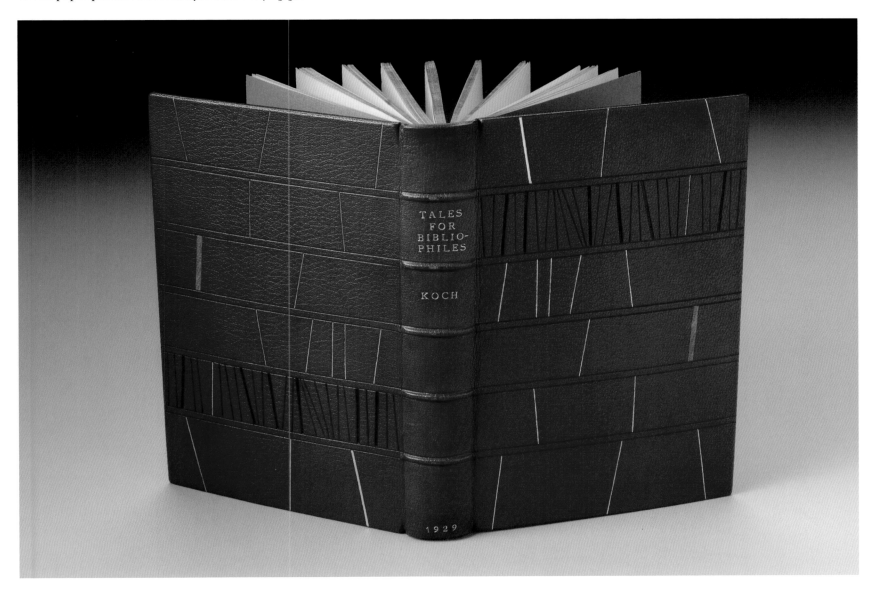

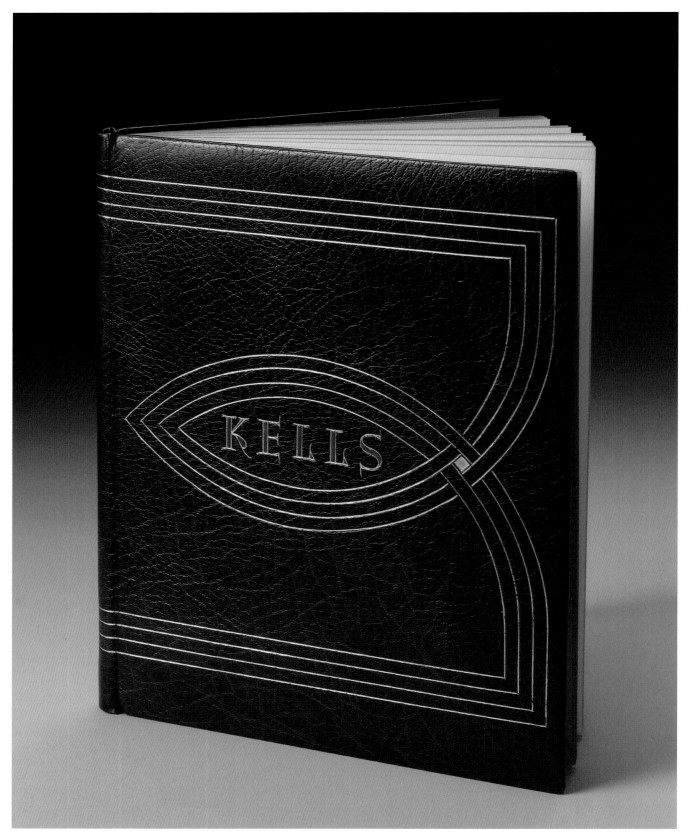

*The Book of Kells*
London & New York:
Studio Publications, 1955
Date of binding 1960

Full green goatskin with title composed of red leather onlay and gold tooling, and gold-tooled Celtic-inspired motif. Handsewn silk endbands. Green goatskin turn-ins with red leather and gold tooling. 11 x 8 3/4 inches.

The turned-in leather and leather hinges of both boards frame the doublures. The leather is decorated with leather onlays and gold tooling.

Bill beveled the edges of the boards to make them appear thinner than they are. He sometimes, as in this case, beveled them with a very gradual taper, but more commonly beveled just at the edges.

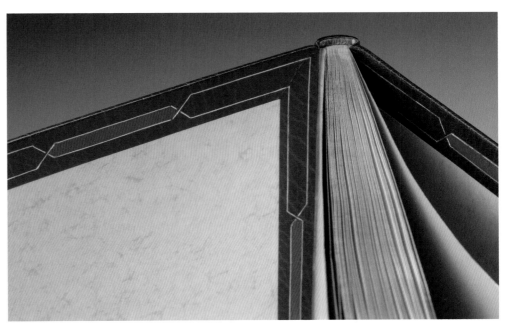

*The Holy Bible*
Chicago: John A. Dickson Publishing Company, 1964
Date of binding 1975

Full brown goatskin with onlay of dark brown leather in form of crucifixion on gold-tooled cross. Edges gilt. Circa 8 x 6 inches.

The edges of the boards of traditional bookbindings are sometimes decorated with blind and gold tooling. Bill tooled the edges of several books in this show, sometimes with one or two lines or, as here, with a pattern from a brass roll.

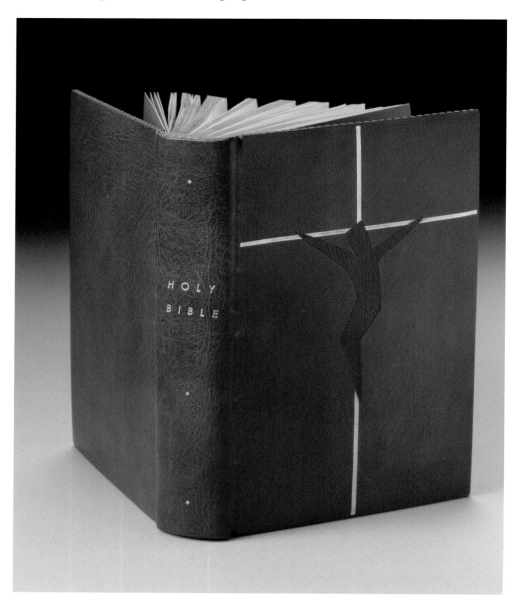

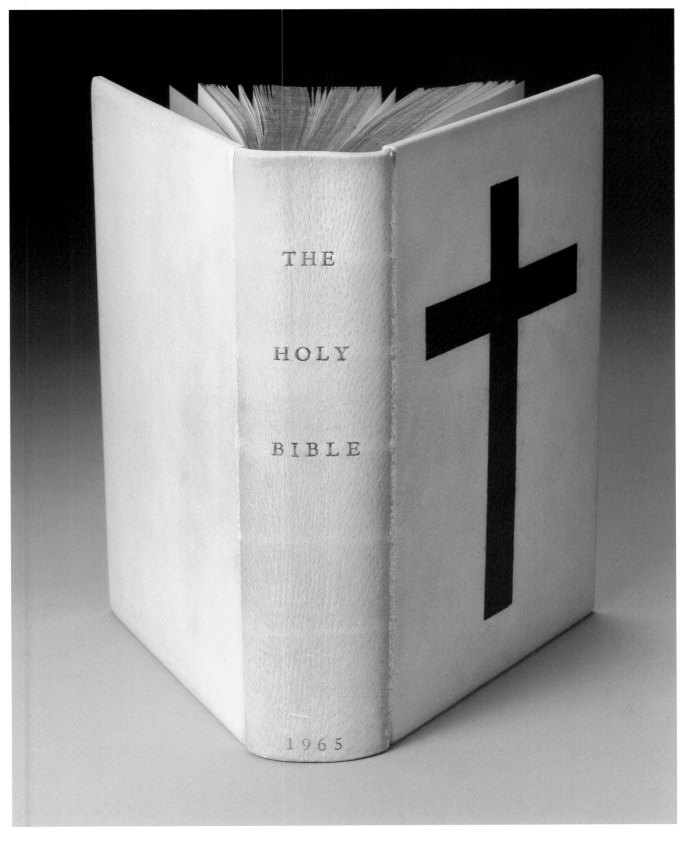

*The Holy Bible*
Chicago: Catholic Press, 1965
Date of binding 1968

Full alum-tawed pigskin with brown oasis onlay in the form of a cross. Handsewn silk endbands. Title blind-tooled on spine. Edges gilt. Vellum doublures with pigskin border and vellum flyleaves. 10 1/2 x 7 1/2 inches.

*Toward Christian Unity: The Inaugural Address of the Second Vatican Council*
by Pope John XXIII, delivered on October 11, 1962
St. Paul: North Central Publishing Company, 1962
Date of binding  1967

Full red goatskin blind-tooled in horizontal linear pattern which forms a hand in
the sign of a blessing. Handsewn silk endbands. Goatskin turn-ins with cream paper
pastedowns and flyleaves. 11 1/2 x 9 inches.

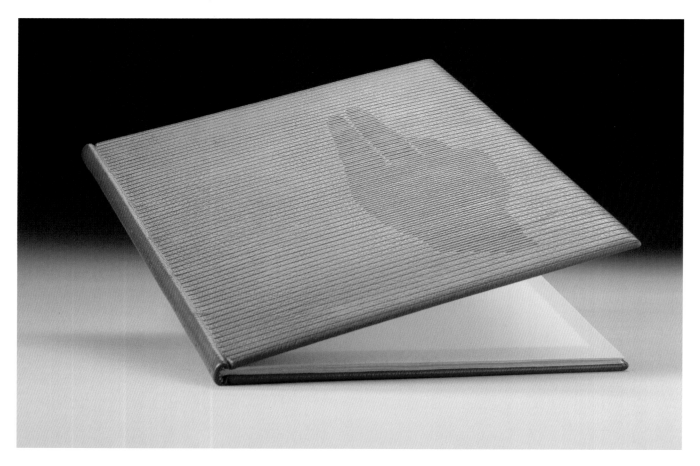

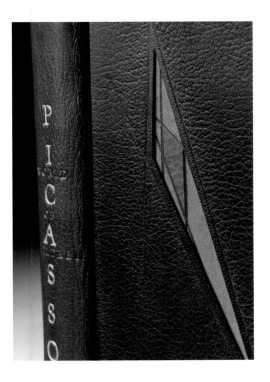

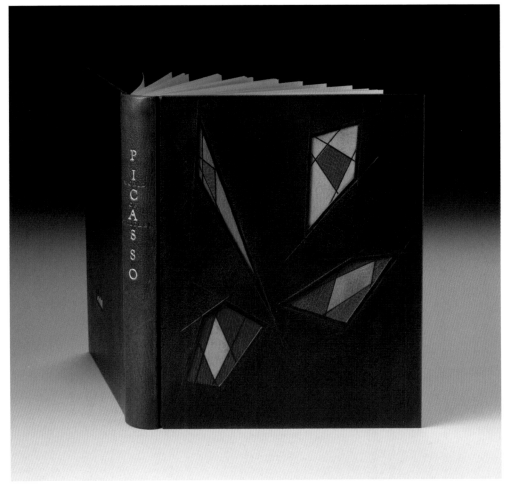

*Picasso's World of Children* by Helen Kay
Garden City, New York: Doubleday & Company, 1965
Date of binding 1977

Full black goatskin with colored goatskin onlays and green goatskin spine. Title blind- and gold-tooled on spine. Black goatskin turn-ins, gold-tooled, with green paste paper pastedowns and flyleaves. Yellow-stained edges. 12 1/2 x 10 inches.

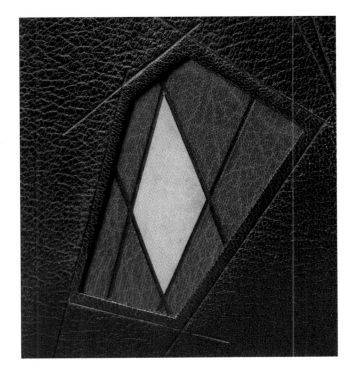

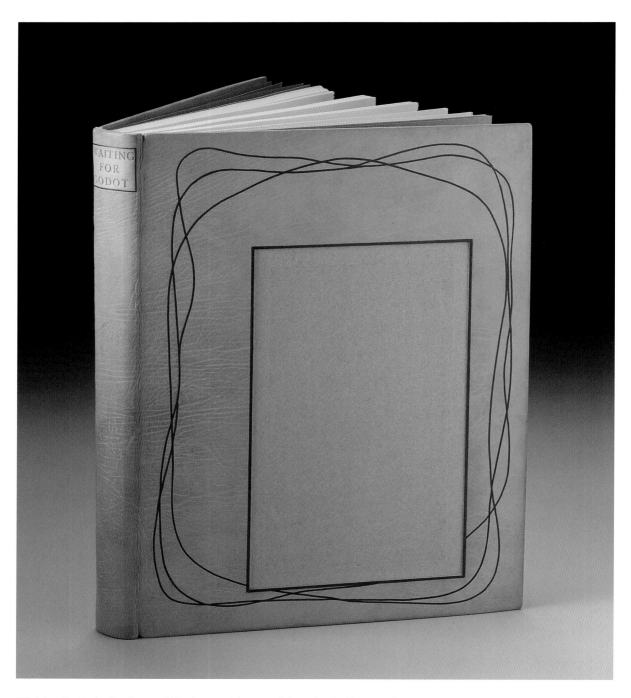

*Waiting for Godot* by Samuel Beckett, with 14 etchings by Dellas Henke
Iowa City, Iowa: Printed by the artist, 1979
Date of binding  1982

Full native-tanned goatskin with purple leather onlays in three overlapping lines around border of cover.
Blank panel 9 3/4 x 6 inches in center of front cover. Handsewn silk endbands. Binding unfinished.
14 1/4 x 11 1/2 inches.

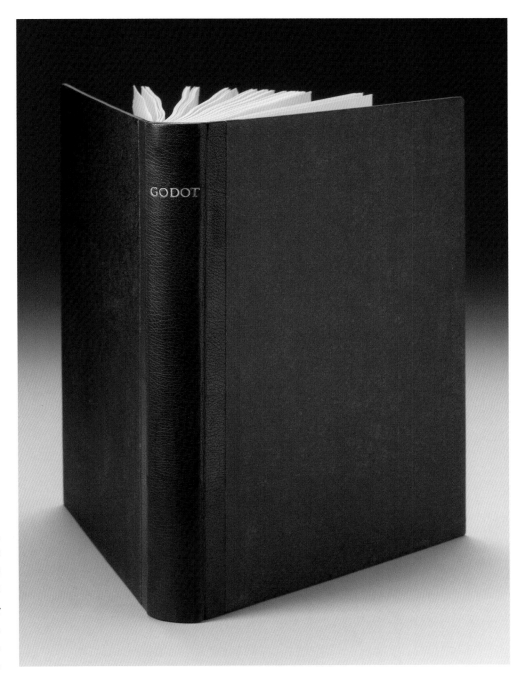

*Waiting for Godot* by Samuel Beckett,
with 14 etchings by Dellas Henke
Iowa City, Iowa: Printed by the artist, 1979
Date of binding 1982

Quarter black goatskin leather with green paste paper
over the boards. Black leather tip. Gold-tooled spine.
Handsewn silk endbands. 14 1/8 x 11 1/2 inches.
Loaned by Annie Tremmel Wilcox.

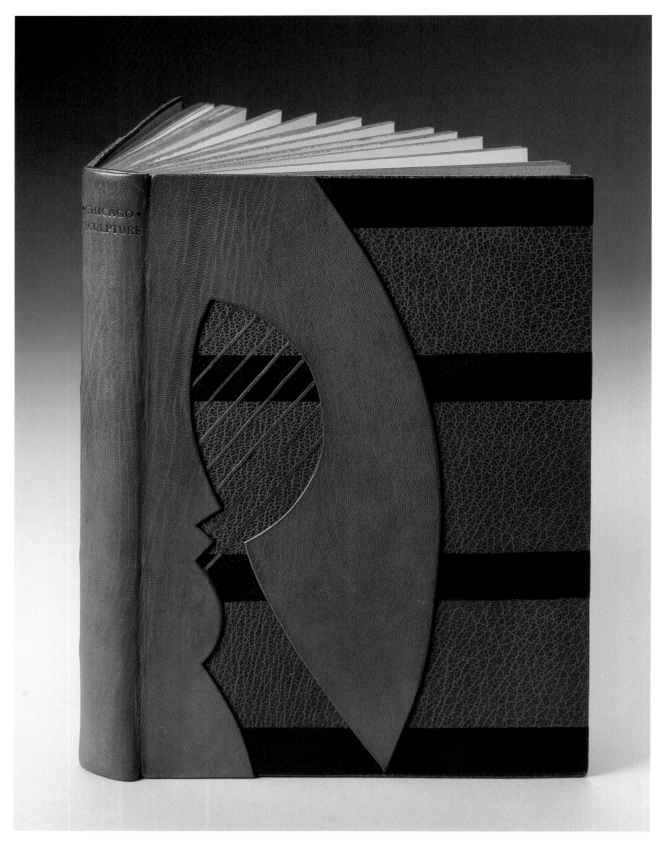

*Chicago Sculpture* by James Reidy
Urbana: University of Illinois
Press, 1980
Date of binding 1980

Full gray levant with onlays of
black leather and red niger in
the form of Picasso's sculpture.
Title blind-tooled on spine.
10 x 7 inches.

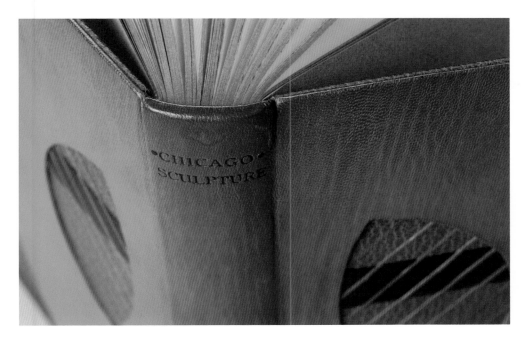

The blind-tooled title harmonizes with the gray edges of the text block, the gray and black leather on the boards, and the black-and-white photographs in the book.

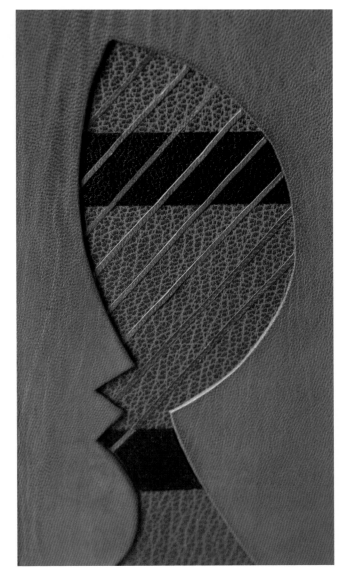

Decorating artistic works presents a dilemma for binders. Bill believed, in such cases, that he had to use the artist's work in some way rather than inventing his own design.

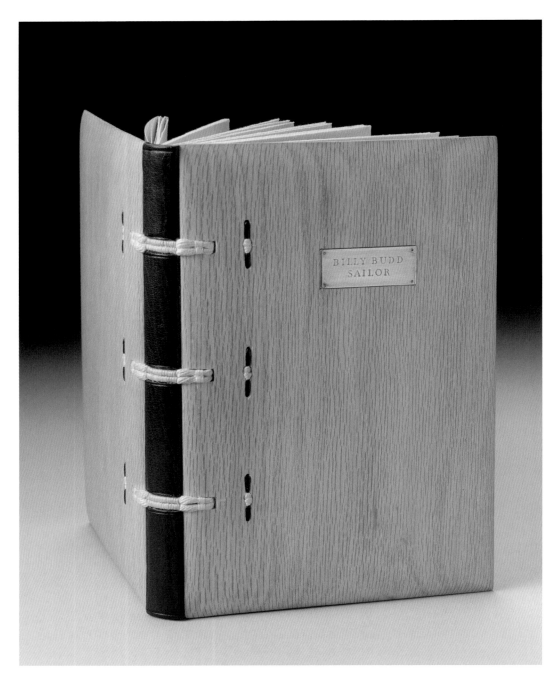

*Billy Budd, Sailor* by Herman Melville
Mount Holly, New Jersey: Married Mettle Press, 1987
Designed and printed by Benjamin and Deborah Alterman
Date of binding 1987

Packed sewing onto doubled linen cords laced onto chamfered oak boards. Spine of green goatskin, blind-tooled with exposed sewing. Title engraved on brass plate inlaid and riveted to front board. Handsewn endbands. Green goatskin doublures with vellum flyleaves.
9 3/8 x 6 3/8 inches. Loaned by John Anthony.

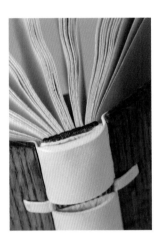

Note how the textblock moves away from the cover spine, an important action since the paper is relatively stiff for such a small book.

Exposed-spine sewing, common in some styles of ancient and medieval bindings, has grown in popularity with modern binders.

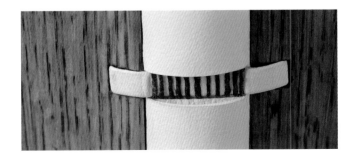

*Ballads and Lyrics of Old France* by Andrew Lang
Portland, Maine: Thomas B. Mosher, 1898
Date of binding 1985

Chamfered oak boards, alum-tawed goatskin spine. Handsewn silk endbands. 8 x 4 inches.

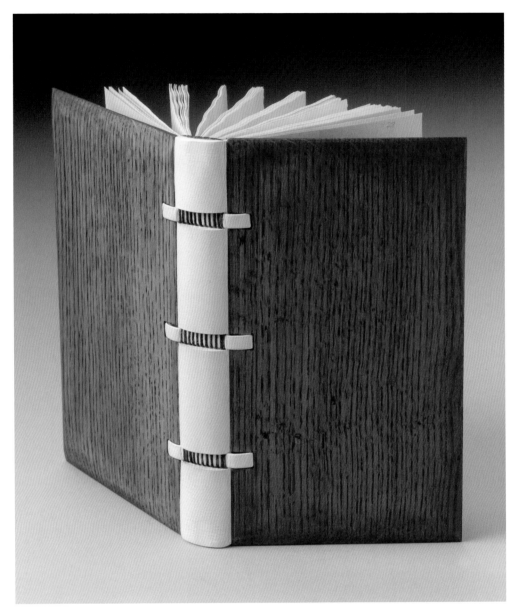

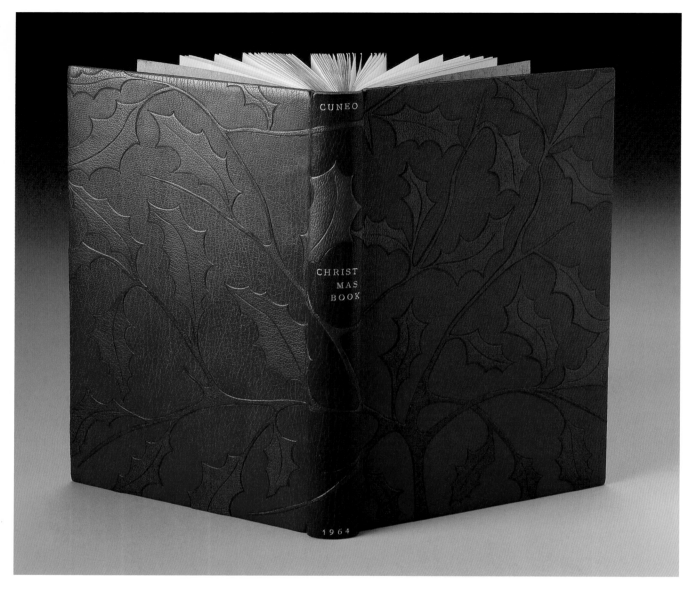

*The Christmas Book*
Chicago: Cuneo Press, 1964
Date of binding  1964

Full brown oasis with green oasis onlays in the form of holly leaves. Title gold-tooled on spine. Handsewn silk endbands. Oasis turn-ins. 9 1/2 x 6 1/2 inches.

Bill's earliest bindings have larger squares and, therefore larger endbands than his later bindings. The earlier endbands, like this one, are more noticeable elements of the book's decoration.

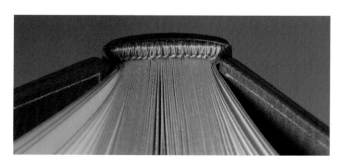

*Birds of the World* by Oliver L. Austin, Jr.
New York: Golden Press, 1961
Date of binding  1980

Full undyed niger goatskin, entirely blind-tooled with lines of longitude and latitude
and forms of flying birds. Title blind-tooled on spine. Sewn on hemp cords with hand-
sewn silk endbands. Edges gilt. Niger turn-ins with pastedowns and flyleaves of
oriental paper with fibers simulating the down or feathers of birds.
13 5/8 x 10 1/8 inches.

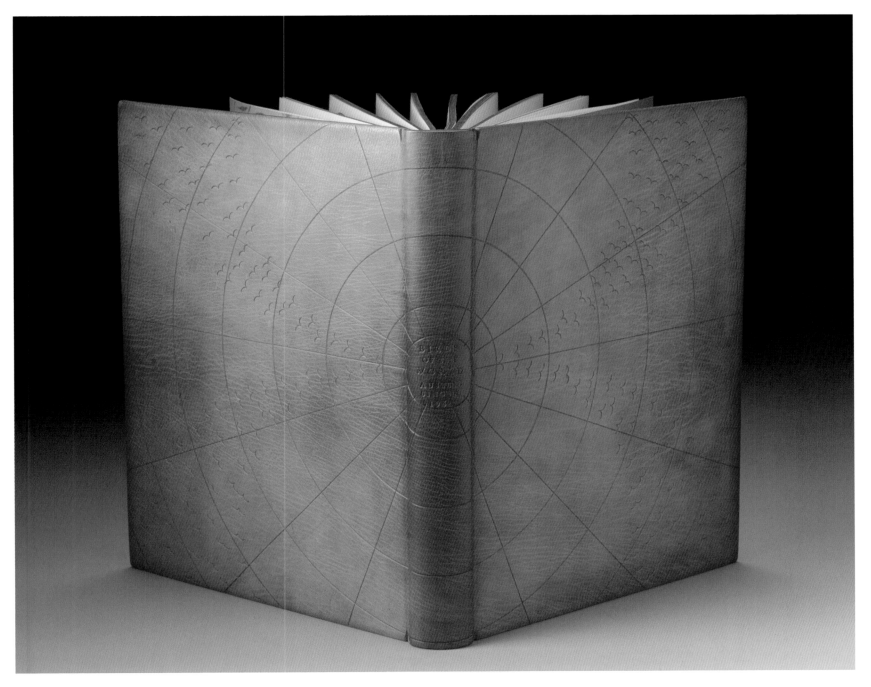

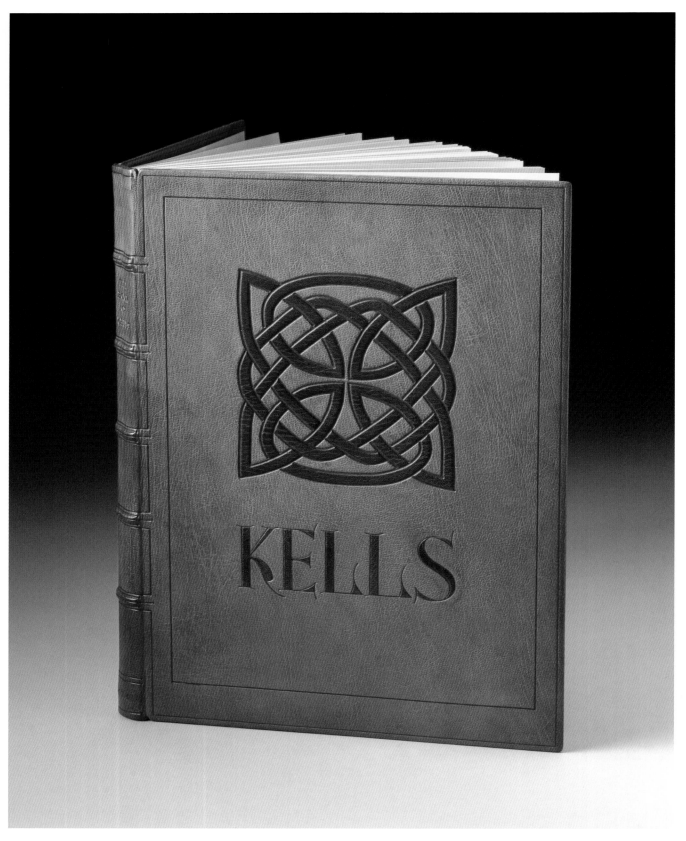

*The Book of Kells*
Reproductions from the
Manuscript in Trinity
College Dublin.
New York: Knopf, 1974
Date of binding 1976

Full native-tanned (rust)
goatskin sewn on five
raised cords. Green
goatskin onlays in form
of Celtic knot and title.
Handsewn silk endbands.
Leather turn-ins and hand-
made paper flyleaves.
13 3/4 x 10 1/2 inches.

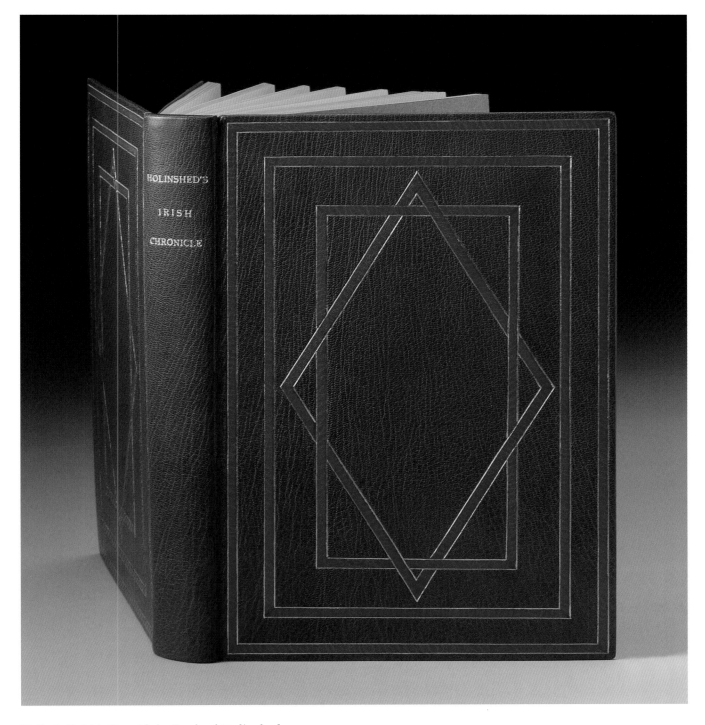

*Holinshed's Irish Chronicle* by Raphael Holinshed
Atlantic Highlands, New Jersey: Humanities Press, 1979
Date of binding 1981

Full green oasis with red leather onlay in rectangular and diamond pattern with gold tooling.
Handsewn silk endbands. Green paper pastedowns and flyleaves. Yellow-stained edges.
10 3/4 x 7 3/4 inches.

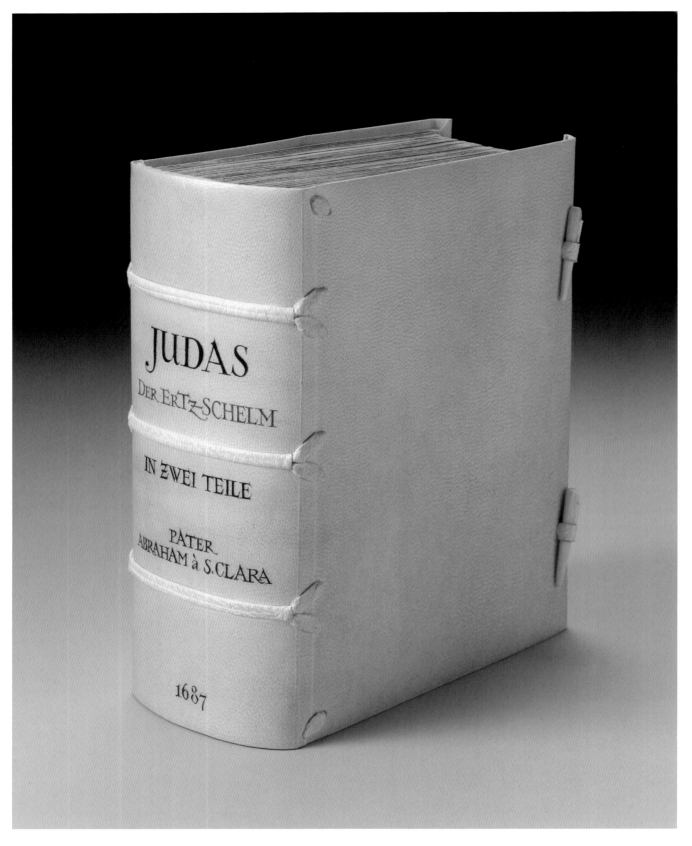

*Judas der Ertz-Schelm*
by Abraham S. Clara
Bonn, Germany: 1687
Date of binding 1980

Full limp goat vellum, sewn on three alum-tawed pigskin thongs with two bone clasps at fore edge. Handsewn linen headbands. Spine hand-lettered by Gertrude Carrier. 7 3/4 x 7 inches.

Bill preferred small tips of vellum or leather on the inside corners of boards. They are a subtle touch, especially when compared with the corners of half leather bindings.

*Company* by Samuel Beckett
Iowa City, Iowa: University of Iowa Center for the Book, 1980

Quarter leather with black paste paper over the boards. Black leather tips. Blind-tooled spine. Edition binding. 14 3/16 x 11 3/8 inches.

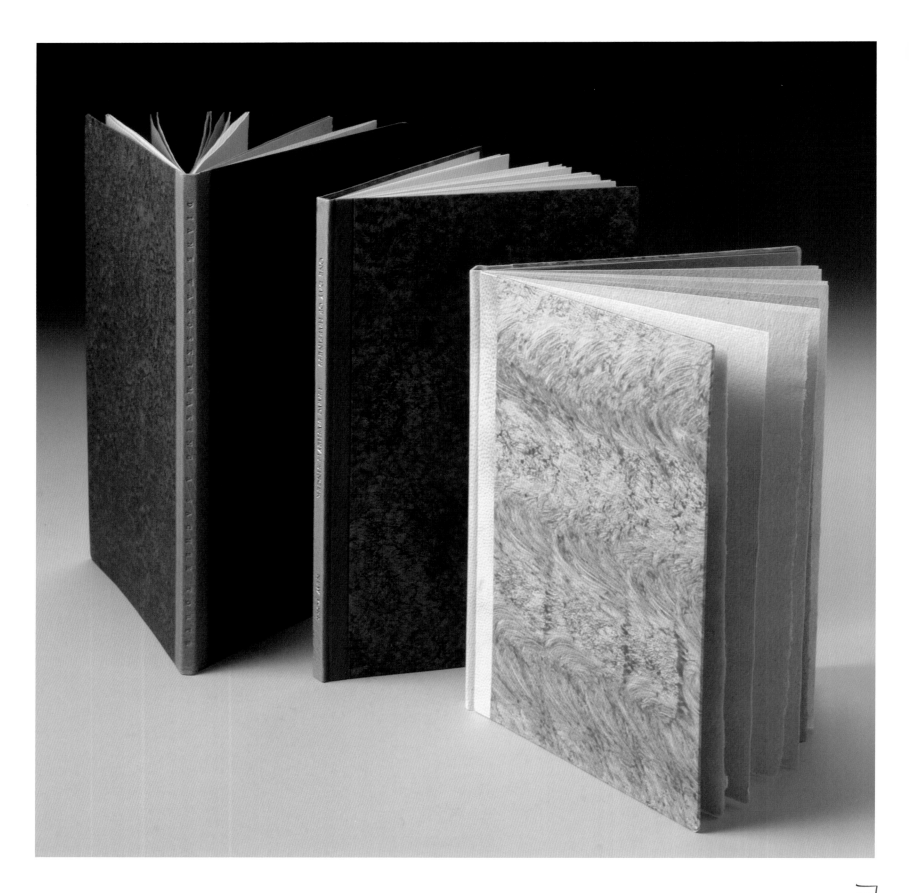

**EDITION BINDINGS**
left to right

*Making a Sacher Torte* by Diane Wakoski
Mt. Horeb, Wisconsin: Perishable Press Limited, 1981

Quarter leather with paste paper over the boards. Blind-tooled spine.
11 1/4 x 7 9/16 inches.

*One Day of Happiness* by Isaac Bashevis Singer
New York: Red Ozier Press, 1982

Quarter leather with paste paper over the boards. Purple leather tips.
Gold-stamped spine. 10 13/16 x 6 3/4 inches. Loaned by Bernadette
Anthony Dowling.

*Last Night* by August Derleth
Mt. Horeb, Wisconsin: Perishable Press Limited, 1978

Quarter vellum with gray paste paper over the boards. Gold-stamped
spine. 9 11/16 x 7 1/16 inches.

*Since Man Began to Eat Himself*
Mt. Horeb, Wisconsin: Perishable Press Limited, 1986
Half cloth with paper over the boards. 11 1/16 x 5 7/16 inches.

*Hand Papermaking* by Walter Hamady
Mt. Horeb, Wisconsin: Perishable Press Limited, 1982
Full cloth. Blind-stamped spine. 11 3/8 x 7 1/2 inches.

*Chapter Seven* by Harry Mark Petrakis
Mt. Horeb, Wisconsin: Perishable Press Limited, 1976
Quarter leather with marbled paper over the boards. Blind-stamped spine.
9 11/16 x 7 3/16 inches.

*Tuft by Puff* by William Stafford
Mt. Horeb, Wisconsin: Perishable Press Limited, 1978
Full cloth. Blind-stamped on front board. 8 1/2 x 5 11/16 inches.

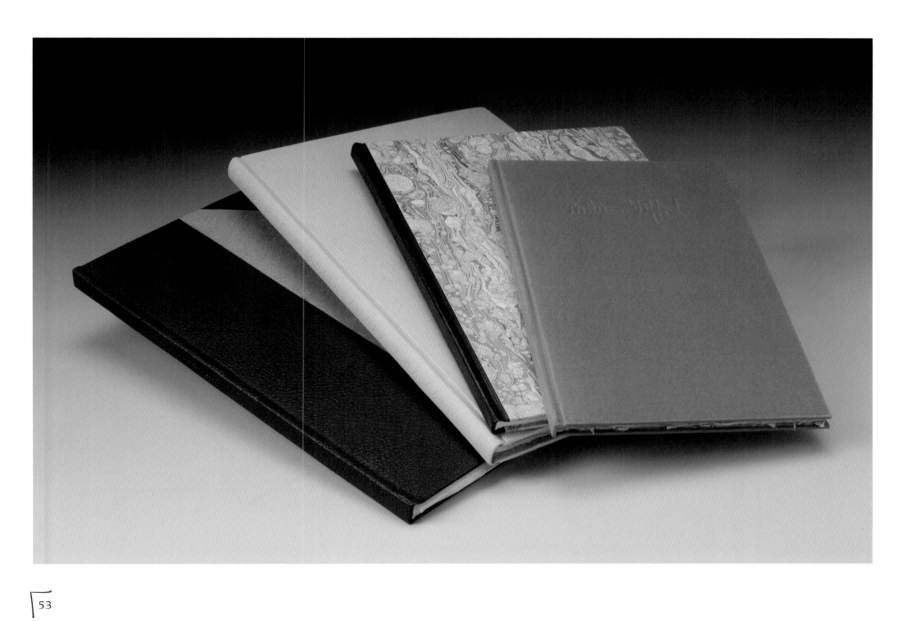

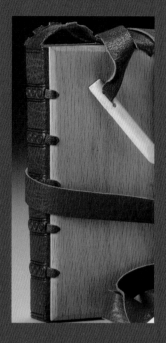

## Conservation Bindings
## & Historical Models

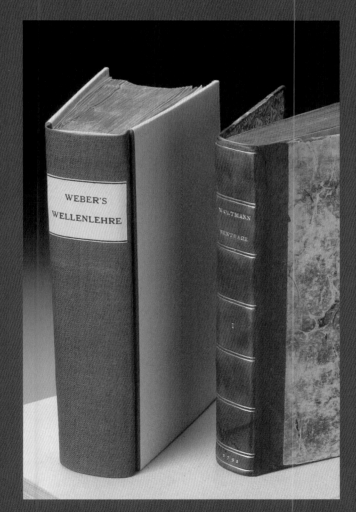

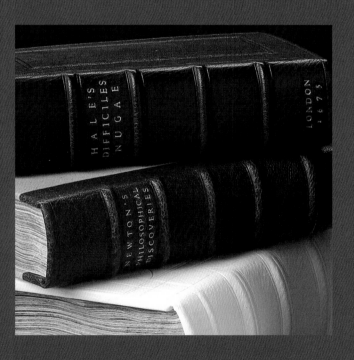

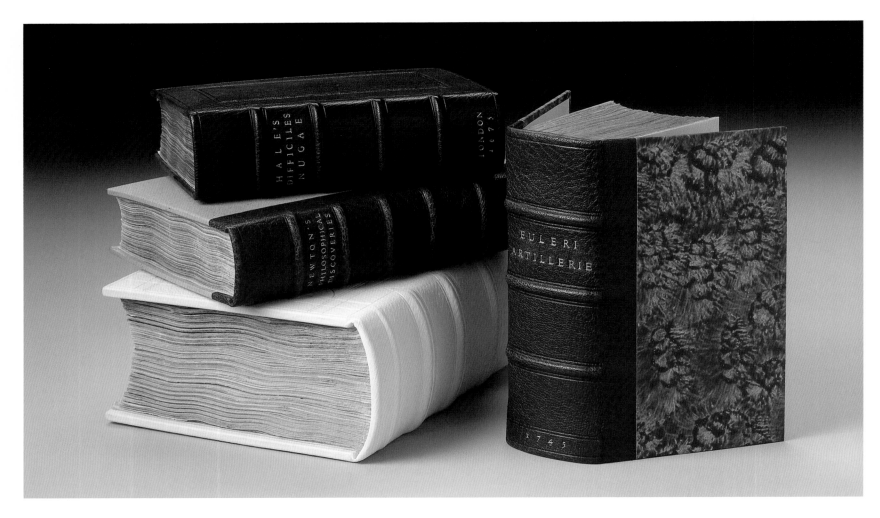

**CONSERVATION BINDINGS** counterclockwise

*Difficiles Nugae* by Sir Matthew Hale
London: Printed by W. Godbid for William Shrowsbury, 1675

Full leather. Blind- and gold-tooled. 6 15/16 x 4 11/16 inches.

*An Account of Sir Isaac Newton's Philosophical Discoveries* by Colin MacLaurin
London: Printed for A. Millar, 1750

Quarter leather with spatter paper over the boards. Blind- and gold-tooled. 8 5/16 x 5 3/8 inches.

*Decem Tractatus Astronomiae* by Guido Bonatti
Augsburg: Erhard Ratdolt, 1491

Full alum-tawed pigskin. Blind-tooled. 8 3/8 x 6 3/4 inches.

*Neue Grundsätze der Artillerie* by Leonhard Euler
Berlin: A. Haude, 1745

Quarter leather with paste paper over the boards. Blind- and gold-tooled. 7 1/8 x 4 1/2 inches.

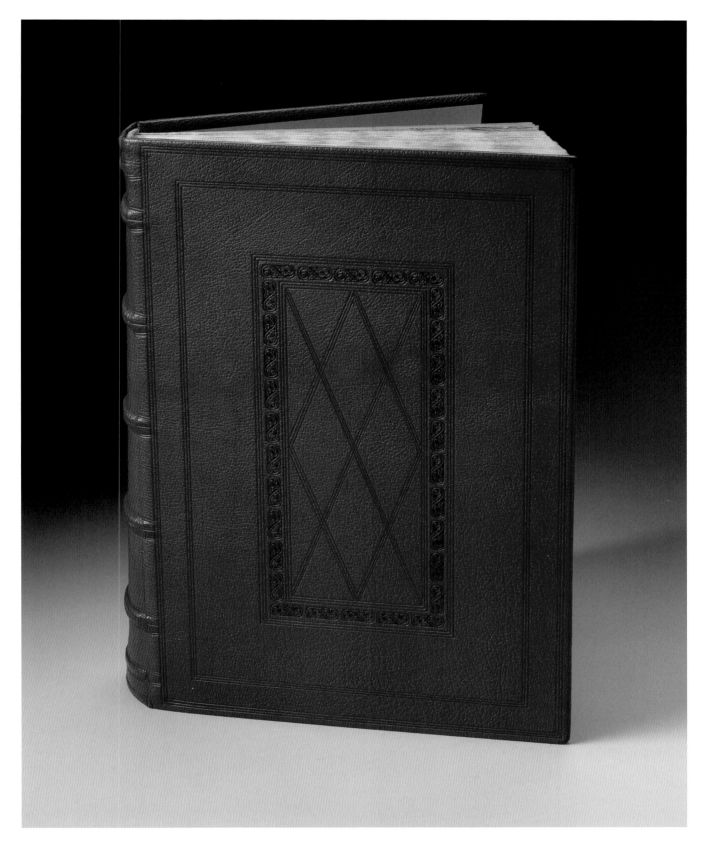

*Liber Chronicarum*
by Schedel Hartmann
Nuremberg:
Anton Koberger, 1493

Full maroon goatskin.
Blind-tooled.
19 1/4 x 13 5/8 inches.

*Liber Chronicarum* by Schedel Hartmann
Nuremberg: Anton Koberger, 1493

Full alum-tawed pigskin. Blind-tooled. 17 3/4 x 12 7/8 inches.

*De Humani Corporis Fabrica* by Andreas Vesalius
Basel, 1555

Full leather. Blind-tooled. 16 3/4 x 11 1/2 inches.

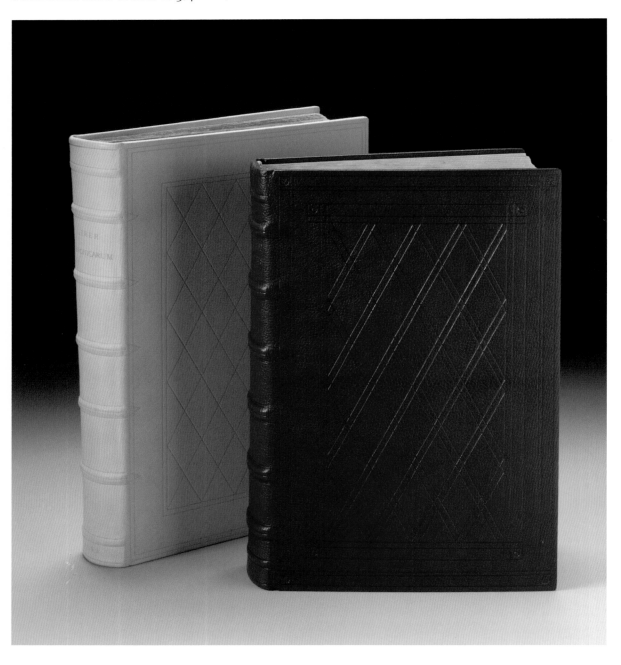

Bill was as concerned with the opening of a book as with the book design. Here we see the magnificent spread of this rare, untrimmed copy of *The Nuremberg Chronicle*.

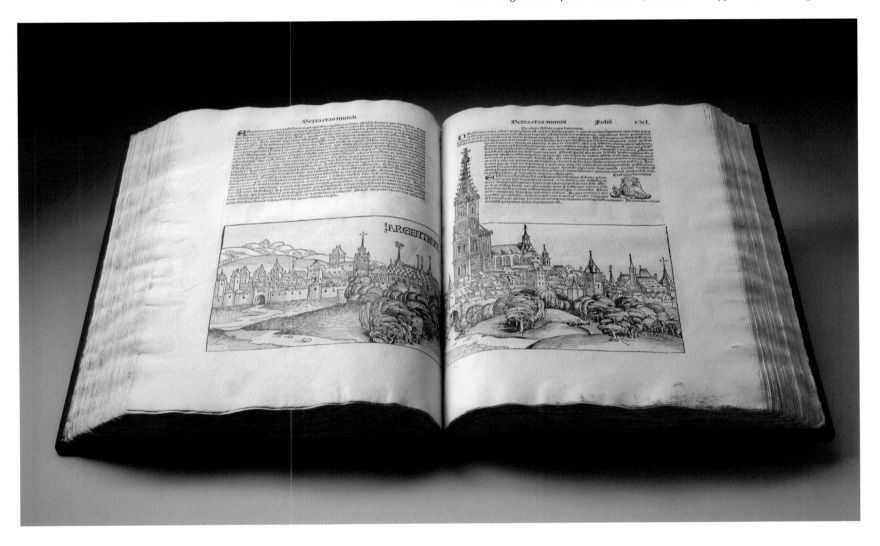

*Lilburne Tracts*
London, etc., 1645–1653

Sixty-one pamphlets in paper covers, boxed.
11 1/4 x 8 1/8 inches.

**CONSERVATION BINDINGS**
clockwise

*Wellenlehre auf Experimente Gegründet*
by Ernst Heinrich Weber
Leipzig: Gerhard Fleisher, 1825
Quarter cloth with paper over the boards.
8 5/16 x 5 1/2 inches.

*Beyträge zur Hydraulischen Architectur*
by Reinhard Woltman
Göttingen: Johann Christian Dietrich, 1791
Rebacked with leather tooled in gold.
8 x 4 7/8 inches.

*Raccolta della Perizie ed Opuscoli Idraulici*
by Leonardo Ximenes
Two volumes. Florence: 1785
Cased in full paper. Stamped paper spine label.
11 5/16 x 8 11/16 inches.

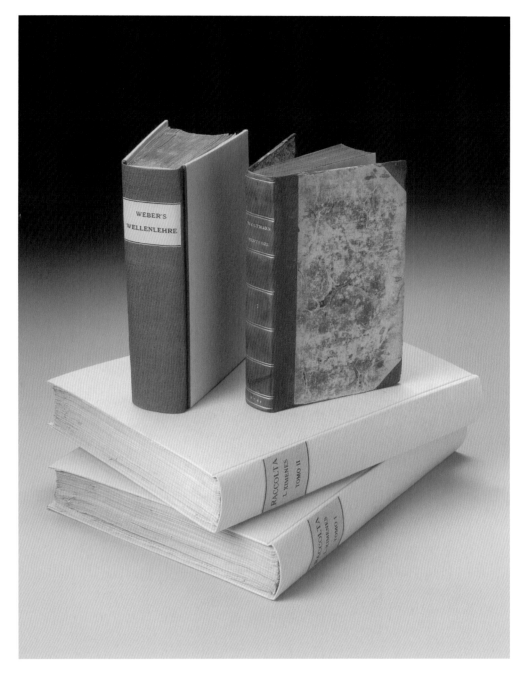

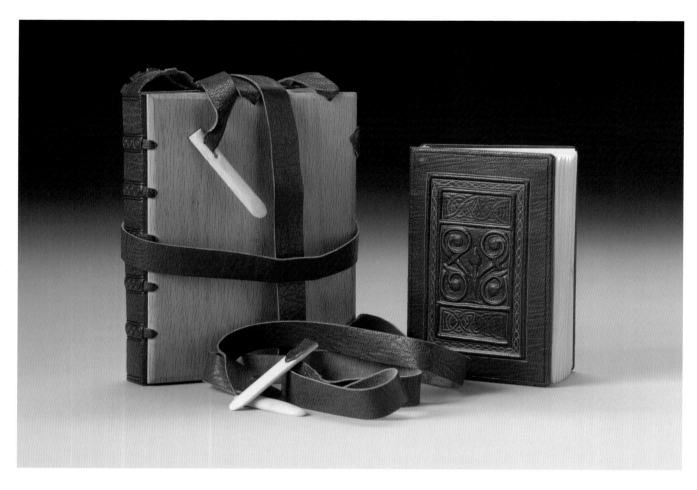

*Model of Coptic book*
Fifth century

Wooden boards. Goatskin spine, hinging strips, and wrapping strips. Blind-tooled. Bone pegs attached to wrapping strips. 6 3/4 x 5 1/4 inches.

*Model of Stonyhurst Gospel*
Seventh century

Full goatskin. Blind-tooled. Paint. 5 3/8 x 3 9/16 inches.

*Model account book*
Fourteenth century

Full vellum with maroon goatskin spine. Blind-tooled. Ornamental exposed sewing. Alum-tawed thongs. 6 1/8 x 5 inches.

*Model of early medieval book*
800–1000 CE
Made by Mark Esser, apprentice to Bill Anthony.

Quarter-sawn oak boards. Alum-tawed supports laced into the boards. Brass clasp. 8 3/8 x 6 5/16 inches.

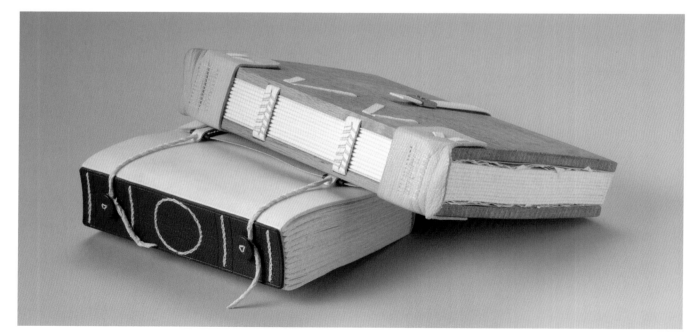

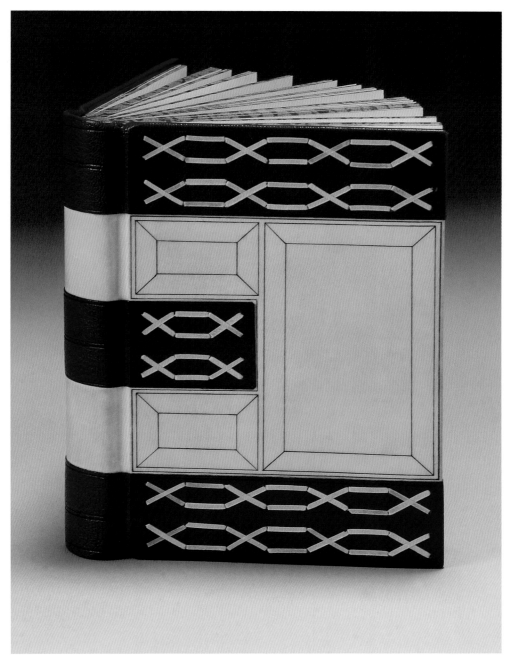

*Model of Russia bander*
Nineteenth century

Full vellum with maroon calfskin attached
to the boards by means of vellum strips.
7 7/8 h x 6 1/8 inches.

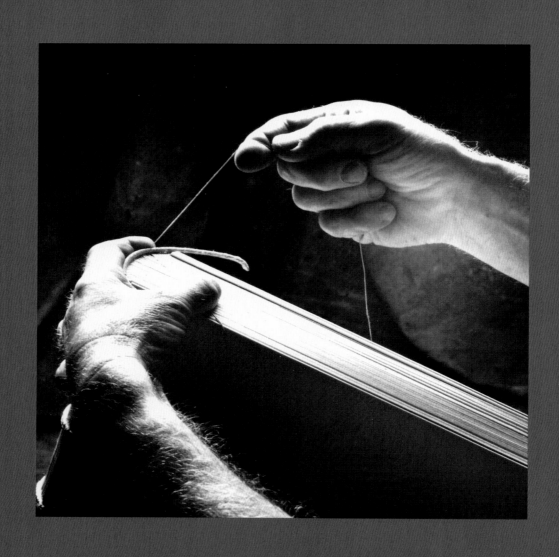

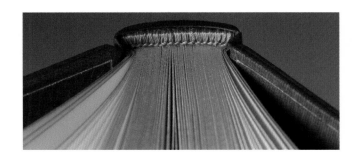

**Glossary**

**ALUM-TAWED SKIN** An animal skin treated with aluminum salts and other materials. The treated skin is bright white when new and ages to a vellum-like yellow. Alum-tawed skin is a very durable book-covering material.

**BLIND STAMPING** Making an impression in the covering material with letters or dies with the aid of a press.

**BLIND TOOLING** Making an impression in dampened leather or other covering material with a heated brass tool.

**BOARDS** The front and back covers of a book. Originally made of wood, the covers are now made of binder's board, a commercial product made of laminated sheets of paper.

**BOOK CONSERVATION** Generally speaking, the attempt to maintain bindings in working order without destroying original materials.

**CAPS** On the book's cover, the area at the head and tail of the spine.

**CASE BINDING** A binding in which the textblock is made up separately from the cover or case. The two are joined by gluing the front and back (blank) leaves of the textblock as pastedowns to the insides of the boards.

**CHAMFERED BOARDS** Boards with beveled edges.

**CODEX** A book with leaves held together at the spine in some way (e.g., sewn, stapled, glued).

**CORDS** The supports around which the sections of a book are sewn. They are commonly made of hemp or linen fibers. The cords may be left as they come off the spool (raised cords) or frayed out to lie flat on the spine.

**DESIGN BINDING** A book that is extensively decorated, often with decoration that is unique to that particular copy of the book and that reflects the book's contents.

**DOUBLURE** A lining for the inside of the boards. Unlike the standard pastedown, it is not a leaf of the textblock.

**EDITION BINDER** One who binds multiples of the same book. Most hand-binders work on editions of 100 to 300 books, usually printed by a fine press.

**ENDBANDS (ALSO HEADBANDS)**  Finishing elements sewn or glued to the head and tail of the textblock. If sewn, the endbands are generally silk thread sewn around a core and into the textblock, through the folds of sections. If glued, the endbands may be cloth specifically manufactured for the purpose or may be made by the binder of some suitable material wrapped around a core.

**ENDPAPERS**  The two or more leaves at the front and back of a book, including the pastedowns.

**EXPOSED SEWING**  A style of binding in which the sewing threads are visible on the spine of the finished book.

**EXTRA BINDING**  A fine binding, usually in leather.

**FINE BINDING**  A book in which the binder's choice of design and materials and his/her execution of all operations are of the highest order.

**FLYLEAVES**  The first and last leaves of a book.

**FULL LEATHER (ALSO FULL CLOTH, FULL PAPER, ETC.)**  A binding in which leather (or other material) covers the spine and boards.

**GILT EDGE**  The edge of a book's text block that has been covered with gold.

**GOLD TOOLING**  Decorating leather or other material with gold leaf. The leather is first blind-tooled in a pattern of the binder's choice; then the tooled impression is treated with glaire (an adhesive substance). The gold leaf is applied in the impression with a hot tool and adheres to the leather.

**HALF LEATHER (ALSO HALF CLOTH, HALF PAPER, ETC.)**  Similar to quarter leather (or other material) binding, except that the material that covers the spine and partially covers the boards also covers the fore-edge corners.

**HANDLE LETTERS**  Brass letters of the alphabet with wooden handles. The binder impresses the heated letters one by one into the leather to create the required words.

**INLAY**  A decoration made by inserting a piece of leather or some other material into a space on the cover of a book where a similarly shaped piece of leather has been cut out. The inlay is usually of a color or texture different from the cover.

**LACING IN**  The process by which the sewing supports for the text block are united with the boards. The cords or tapes to which the sections are sewn are pulled through holes or slots at the spine edges of the boards.

**LEAF / LEAVES**  Each unit of paper within a book, numbered with an odd number on one side (recto) and with an even number on the other (verso).

**LEVANT**  Goatskin leather with a distinctive grain, originally from the Middle East, now typically from north Africa.

**LIMP BINDING**  A binding which does not have stiff boards. The most common limp bindings are covered in leather or vellum.

**MARBLED PAPER**  Decorated paper used by bookbinders to cover boards and as endpapers. In the marbling process, colors are floated on thickened water and are transferred to a prepared piece of paper when the marbler lays the paper on the surface of the water.

**NIGER**  A goatskin leather with a distinctive grain and (commonly) orange color, produced in north Africa.

**NIPPING PRESS**  A device consisting of a flat bed (below) and a platen (above). The platen can be lowered by means of a screw to put pressure on an object lying on the bed.

**OASIS**  A goatskin leather with a smoother surface than other goatskins, produced in north Africa.

**ONLAY**  A decoration made by laying a very thin piece of leather onto the surface of a leather binding. The onlay is usually of a color different from the cover.

**PACKED SEWING**  A method of sewing a book on raised cords. The binder wraps the sewing thread around the cord to fill the space between the sections before sewing the next section.

**PASTEDOWN**  The outside leaf of the textblock that is glued to the inside of the board to join text block to cover.

**PASTE PAPER**  Decorated paper used by bookbinders to cover boards. The binder mixes paint with paste, brushes the mixture on the paper, and then manipulates the paint mixture to create the desired effect.

**QUARTER LEATHER (ALSO QUARTER CLOTH, QUARTER PAPER, ETC.)**  A binding in which the leather (or other material) that covers the spine is brought over the boards to partially cover them, while another material covers the remainder of the boards.

**QUARTER-SAWN BOARD**  Wood cut so that the grain runs head to tail, making the wood resistant to warping.

**REBACKING**  In conservation, the placing of new material over the spine of a book. If the original spine still exists, it is then attached to the outside of the new material.

**ROLL**  A brass wheel with a long wooden handle. When the roll is heated, the edge of the wheel is used to tool lines or other designs in leather.

**RUSSIA BANDER** A style of blank book made in the nineteenth century that has its spine reinforced with leather bands.

**SECTION (ALSO SIGNATURE OR QUIRE)** Pieces of paper folded, then sewn through the fold and joined to other sections to make a textblock.

**SPATTER PAPER** Decorated paper typically used to cover boards. The binder sprinkles paint(s) on the paper to create the decoration.

**SQUARE** On the inside of the front and back covers of the book, the amount of board showing beyond the head, fore edge, and tail of the text block.

**TIGHT-BACK** A book in which the spine of the textblock is adhered to the spine of the cover.

**TURN-IN** The covering material that wraps over the edge and is glued to the inside of the boards.

**VELLUM** An animal skin, often sheepskin or calfskin, that has been put in a lime bath, dehaired, scraped, and stretched. It may be used for the leaves or the covers of books.

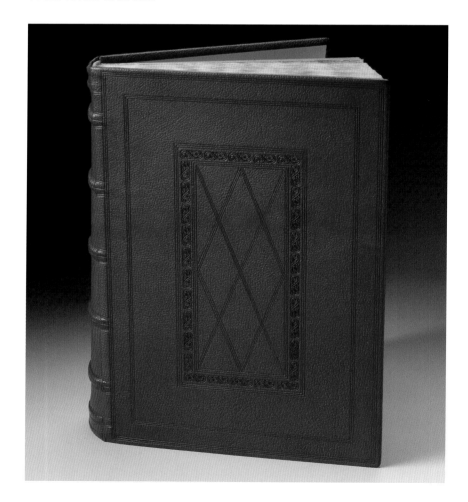

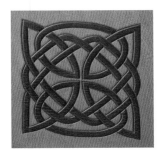

## Professional History

*William Anthony 1926–1989*

| | |
|---|---|
| 1942–1949 | Apprenticeship in bookbinding, Croker & Co., Waterford, Ireland |
| 1949–1951 | Journeyman bookbinder, Healy's, Dublin, Ireland |
| 1951–1954 | Journeyman bookbinder, Clarendon House, Oxford University Press, London |
| 1954–1957 | Journeyman bookbinder, Watkins & Watkins, London |
| 1954–1956 | Studied at Camberwell College of Arts, London |
| 1957–1959 | Journeyman bookbinder, Bailey Bros., Croydon |
| 1959–1964 | Journeyman bookbinder, F. G. Marshall, Surrey |
| 1961–1962 | Studied fine binding at Sutton School of Art, London |
| 1963–1964 | Taught at Camberwell School of Art, London |
| 1964–1973 | Studio director, Cuneo Press, Chicago |
| 1964–1967 | Taught at the John Crerar Library, Chicago |
| 1966–1967 | Studied typographic design at the University of Chicago |
| 1966–1967 | Studied design at the Illinois Institute of Technology, Chicago |
| 1967–1984 | Taught privately in Chicago |
| 1973–1982 | Senior Partner, Kner & Anthony Bookbinders, Chicago |
| 1980 | Founding member, Chicago Hand Bookbinders |
| 1982–1984 | President, Anthony & Associates, Bookbinders, Inc., Chicago |
| 1984–1989 | University conservator, University of Iowa, Iowa City |
| 1985–1988 | Chair, Standards Committee, Guild of Book Workers |

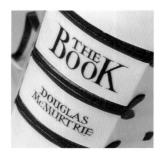

Title Index